weekend
HATS

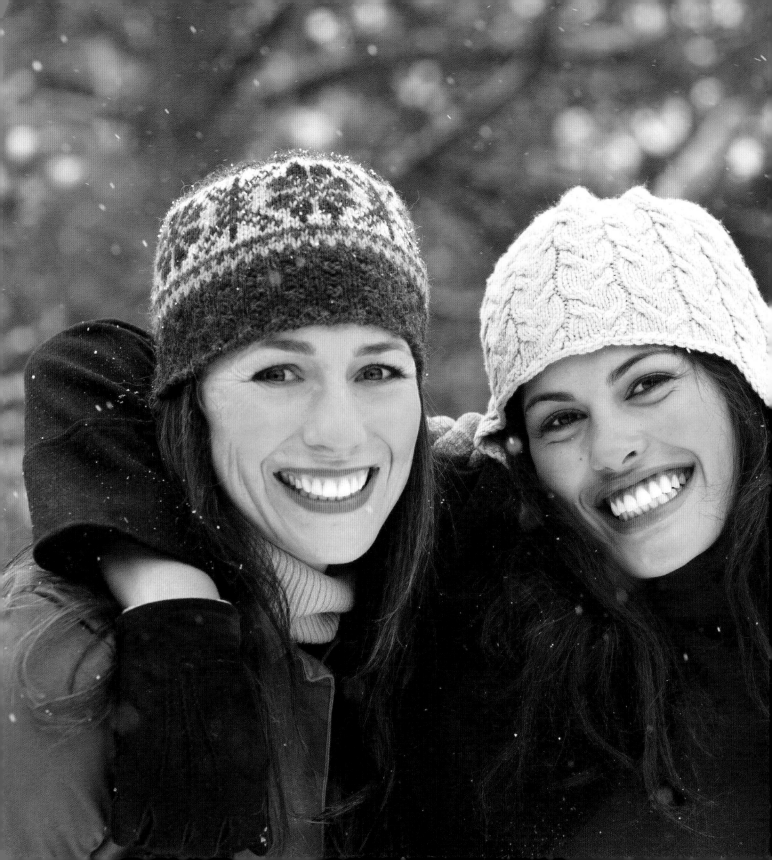

weekend
HATS

25 knitted caps, berets, cloches, and more

cecily glowik macdonald
melissa labarre

INTERWEAVE
interweave.com

To the memory of Stella S. and her lifelong love of hat knitting. She will be missed.

Acknowledgments

We would like to thank the wonderful team at Interweave for believing in and getting excited about this project. Huge thanks to the wonderful designers who participated in this project: Gudrun Johnston, Kate Gagnon Osborn, Courtney Kelley, Carrie Bostick Hoge, Connie Chang Chinchio, Mary Jane Mucklestone, Jocelyn J. Tunney, Jared Flood, Elisabeth Parker, Tanis Gray, Susan B. Anderson, Anne Kuo Lukito, Kirsten Kapur, Natalie Larson, Laura Irwin, Jennifer Lang-MacKenzie, Melissa Wherle, Kristen TenDyke, and Cirilia Rose. We were overwhelmed by the beautiful hats you created.

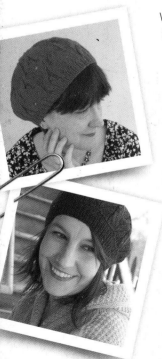

We are also grateful to the following yarn companies that generously provided yarn for the projects: Valley Fibers/Webs, Bijou Basin Ranch, Berroco, Blue Sky Alpacas, Knitting Fever/Sublime, Malabrigo Yarn, Fairmount Fibers/Manos del Uruguay, Classic Elite Yarns, Cascade Yarns, Rowan/Westminster Fibers, Quince and Co., Brooklyn Tweed, Tunney Wool Company/O-Wool, Kelbourne Woolens/Fibre Company Yarns, and St-Denis Yarns.

Many thanks to our family and friends, who endured another year of new-book talk. Without their support and enthusiasm, we wouldn't have been able to do it again.

We are very grateful to all the knitters who have knit from our patterns. Happy knitting!

Cecily and Melissa

EDITORS Anne Merrow and Ellen Wheat
TECHNICAL EDITOR Kristen TenDyke
ART DIRECTOR Liz Quan
DESIGNER Julia Boyles
PHOTOGRAPHY Joe Hancock
ILLUSTRATION Ann Swanson
PRODUCTION Katherine Jackson

Interweave Press LLC
201 E. 4th St.
Loveland, CO 80537
interweave.com

Printed in China by C&C Offset.

Library of Congress Cataloging-in-Publication Data

MacDonald, Cecily Glowik.
 Weekend hats : 25 knitted caps, berets, cloches, and more / Cecily Glowik MacDonald, Melissa LaBarre.
 p. cm.
Includes bibliographical references and index.
 ISBN 978-1-59668-438-6 (pbk.)
 1. Knitting--Patterns. 2. Caps (Headgear) 3. Hats. I. LaBarre, Melissa. II. Title.

TT825.M1536 2011
746.43'2--dc23

2011019905

10 9 8 7 6 5 4 3 2 1

Contents

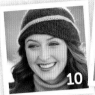
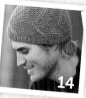
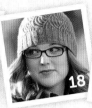
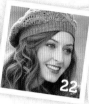

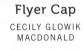

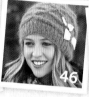
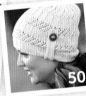
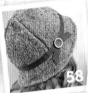

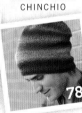
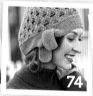
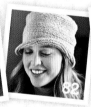
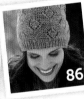

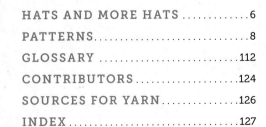

Hats and More Hats

We love knitting hats. They are small, portable projects, great for tucking into your everyday bag and knitting on trains and buses. Hats are the perfect little knits for passing time in waiting rooms or stitching during meetings.

Hats provide the opportunity to try new techniques without committing to a bigger project, such as a sweater. They allow us to indulge in luxury yarns that we might not invest in for larger projects. Best of all, hats can be quickly knitted and make great handmade gifts.

As designers, we find ourselves casting on for hats when we need a break from that never-ending sweater. We make them as large swatches for a stitch pattern we've wanted to try. We cast on again and again, never tiring of the near-instant gratification that knitting a hat provides.

We both love books that focus on one type of project and showcase personalized versions of that project created by popular and innovative designers. So, that's what we've done here. We asked some of our favorite designers to design a hat that they would love to wear or would love to make for someone. They gave us cables, lace, colorful designs, berets, beanies, earflaps, and a fun assortment of stitches. We love how the designs incorporate both traditional techniques and modern details that make the hats exciting to wear. We think you'll enjoy what they've come up with as much as we do. Not just for snowy weather, these twenty-five new hat designs will turn the heads of stylish knitters everywhere.

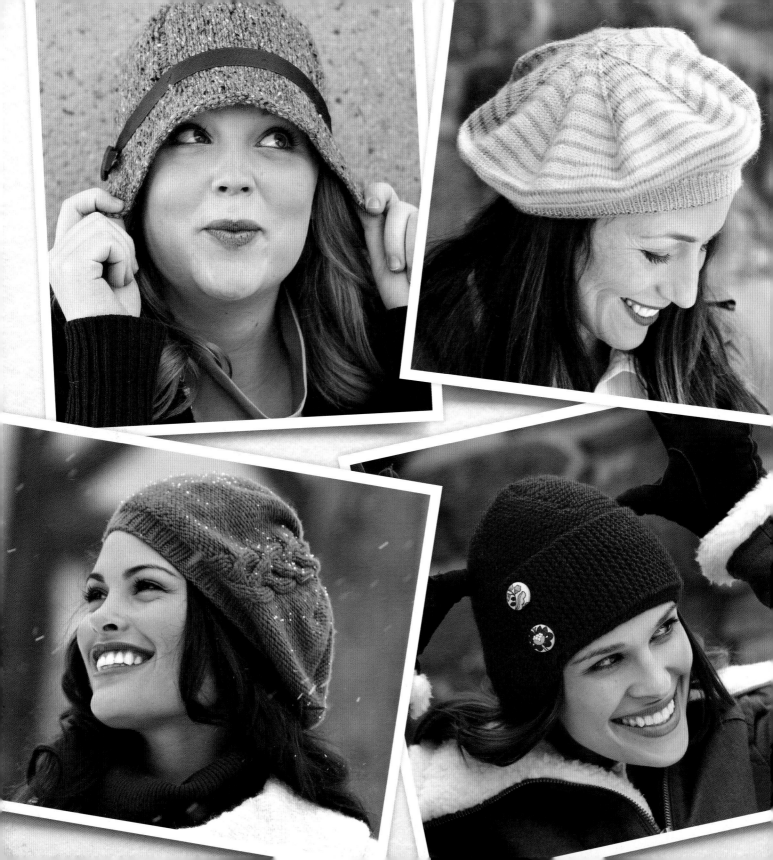

Patterns

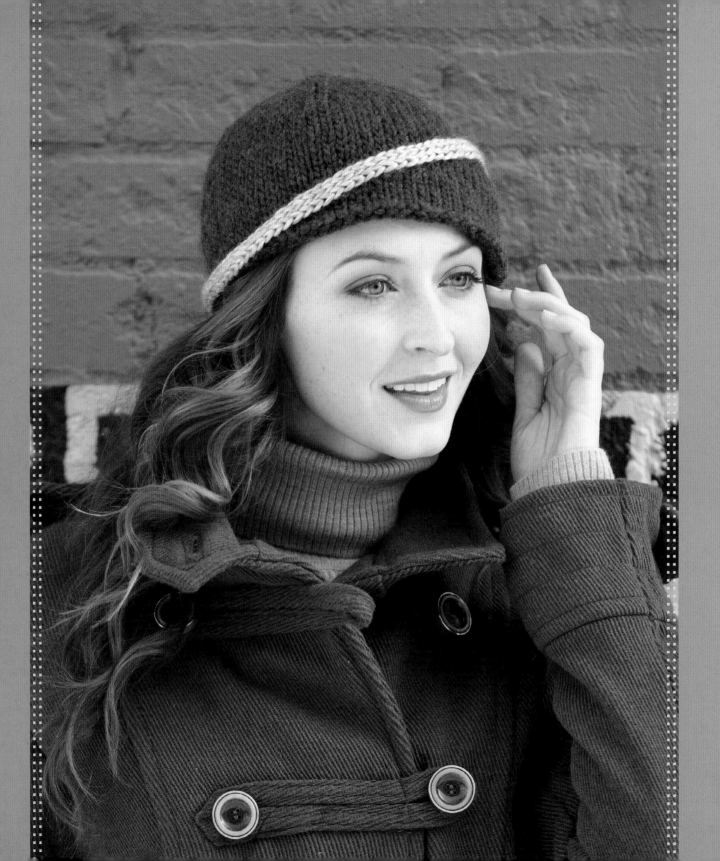

PLAIT BEANIE

BY ANNE KUO LUKITO

A folded-over brim with contrasting trim adds a modern, asymmetric design element to a simple cap shape. Worked in a soft bulky-weight yarn, this hat is a very quick knit, but has perfectly finished details that make it appear far more complicated.

materials

YARN
Bulky #5 (bulky weight).
Shown here: Classic Elite Ariosa
(90% extrafine merino, 10% cashmere;
87 yd [80 m]/50 g): #4879 damson (MC),
2 skeins; #4803 foam (CC), 1 skein.

NEEDLES
U.S. size 10 (6 mm): 16" (40 cm) circular
(cir) and set of 4 double-pointed (dpn).
Adjust needle size if necessary to obtain
the correct gauge.

NOTIONS
Markers (m), tapestry needle.

GAUGE
14 sts and 19 rows/rnds = 4" (10 cm)
in St st.

FINISHED SIZE
20½" (52 cm) circumference at brim;
to fit 20½–22½" (52–57 cm) head
circumference.

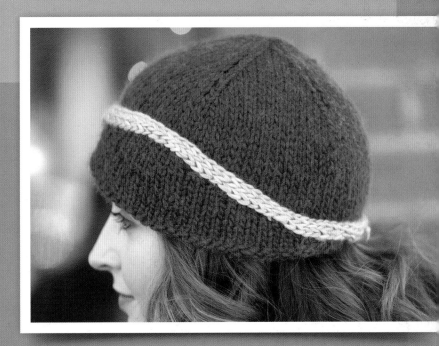

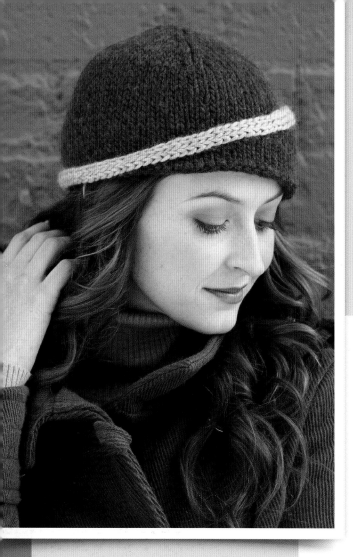

The hat is worked in one piece, starting from the brim, which is worked back and forth. After the brim shaping is complete, stitches are cast on for the hat body and stitches are joined for working in the round. Once the hat body is finished, an I-cord edging in a contrasting color is worked around the edges to finish off the hat.

3½" (9 cm)

4¼" (11 cm)

3" (7.5 cm)

21½" (52 cm)

BRIM

With MC and cir needle, CO 9 sts.

Next row: (WS) Purl.

Working back and forth in St st, shape brim as foll:

Use the knitted method (see Glossary) to CO 2 sts at beg of next 4 rows—17 sts. CO 3 sts at beg of next 6 rows—35 sts. CO 2 sts at beg of next 2 rows—39 sts.

CO 3 sts at beg of next row—42 sts.

BODY

Next row: (WS; turning row) Use the cable method (see Glossary) to CO 30 sts, knit to end—72 sts.

Pm and join for working in the rnd, being careful not to twist sts. Knit until hat body measures 4¼" (11 cm) from turning row. (Note that the WS of the brim has now become the RS of the body. When finished, the brim is folded at the turning row so the RS of the brim and body will both be showing.)

SHAPE CROWN

Note: Change to dpns when there are too few sts to work comfortably on cir needle.

Set-up rnd: *K18, place marker (pm); rep from * to end of rnd.

Next rnd: Knit.

Next rnd: (dec rnd) *Ssk, knit to 2 sts before marker, k2tog; rep from * to end of rnd—8 sts decreased.

Rep last 2 rnds 6 more times—16 sts rem.

Next rnd: (dec rnd) *K2tog, remove marker; rep from * to end—8 sts rem.

Break yarn, leaving a 4" (10 cm) tail. Thread tail onto tapestry needle and draw through rem sts, pull snug to tighten, and fasten off inside.

EDGING

Turn up brim along turning row so that the RS of brim and body are both facing. Block with steam to prevent curling.

With CC and dpns, work applied I-cord edging along brim and body edge as foll:

With 1 dpn and using a provisional method (see Glossary), CO 4 sts. With RS facing, beg where brim was joined for working in the rnd, pick up and knit 1 st along CO edge of hat—5 sts on dpn. With RS still facing, slide sts to right-hand end of dpn.

Next row: K3, k2tog tbl, pick up and knit 1 st along CO edge of hat; with RS still facing, slide sts to right-hand end of dpn.

Rep last row around hat until all CO edge sts are joined. Remove provisional CO sts and place revealed sts on an empty dpn. Use Kitchener st (see Glossary) to graft last row to CO row.

FINISHING

Weave in ends. Block. After blocking, the brim should stay flipped up, but it can be tacked in place if desired.

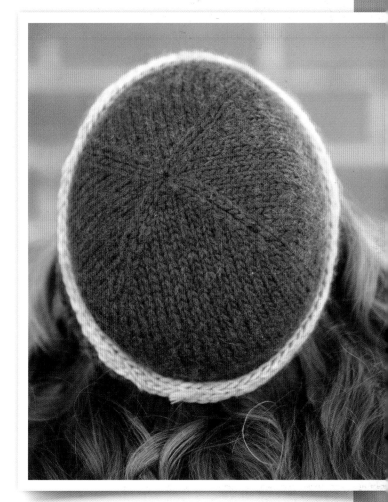

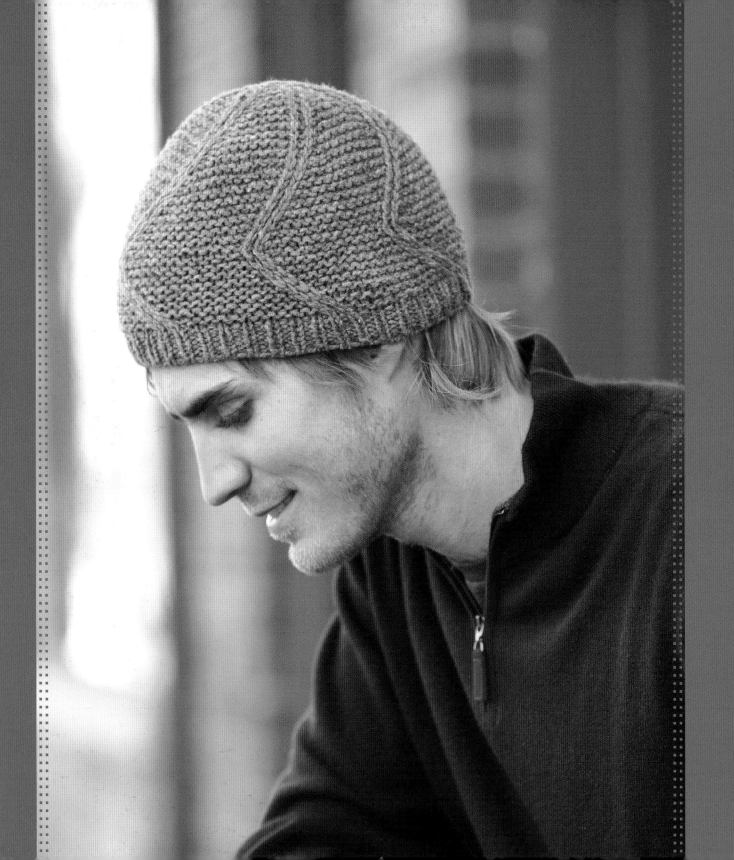

WANDERER CAP
BY JARED FLOOD

Knit with a rustic tweed yarn, a zigzag pattern adds a simple yet bold detail to this quickly stitched, classic cap that's perfect for the men in your life. The design flows seamlessly from the ribbed band, for a flawless finished look.

materials

YARN
Medium #4 (worsted weight).
Shown here: Brooklyn Tweed Shelter (100% American wool; 140 yd [128 m]/50 g): #04 hayloft, 1 skein.

NEEDLES
Ribbing—U.S. size 7 (4.5 mm): 16" (40 cm) circular (cir). *Body—U.S. size 8 (5 mm):* 16" (40 cm) cir and set of 4 double-pointed (dpn). Adjust needle sizes if necessary to obtain the correct gauge.

NOTIONS
Marker (m); cable needle (cn); tapestry needle, waste yarn.

GAUGE
18 sts and 36 rnds = 4" (10 cm) in garter st on larger needle.

FINISHED SIZE
21¼" (54 cm) circumference at widest point, unstretched; to fit head circumference 20–23" (51–58.5 cm).

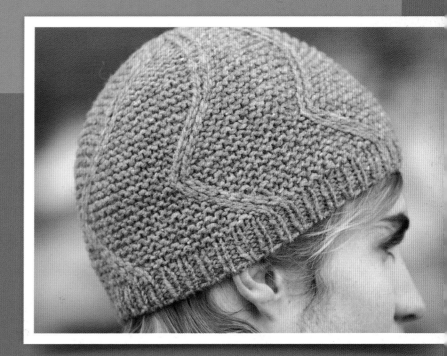

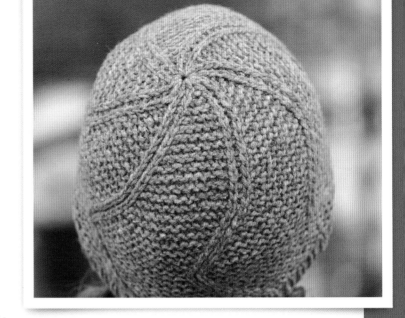

Stitch Guide

Left Twist (LT)
Sl 1 st onto cn and hold in front, k1 from left needle, k1 from cn.

Right Twist (RT)
Sl 1 st onto cn and hold in back, k1 from right needle, k1 from cn.

RIBBING

With smaller cir needle and using tubular method (see Glossary), CO 88 sts. Place marker (pm) and join for working in the rnd, being careful not to twist sts.

Rnd 1: *K1, p1; rep from * to end.

Rep last rnd until piece measures 1" (2.5 cm).

BODY

Next rnd: (inc rnd) *K14, M1 (see Glossary), k30, M1; rep from * once more—92 sts.

Next rnd: *Sl 1 purlwise (pwise) with yarn in back (wyb), p1, sl 1 pwise wyb, p12, sl 1 pwise wyb, p1, sl 1 pwise wyb, p13, sl 1 pwise wyb, p1, sl 1 pwise wyb, p12; rep from * once more.

Change to larger cir needle.

Next rnd: (inc rnd) LT (see Stitch Guide) 2 times, k11, M1, LT 2 times, k12, LT 2 times, k11, m1; rep from * once more, remove m, sl 1 pwise wyb, pm for beg of rnd—96 sts.

Work Rnds 1–14 of Silo Chart moving the marker at the end of each even numbered rnd.

Next rnd: Work Rnd 15 to end of rnd. Remove m, slip 3 sts from left to right needle, pm for new beg of rnd.

Next rnd: Work Rnd 16 to last 2 sts of rnd, sl 1 st to cn, hold in back, k1, slip beg of rnd m, return st on cn to left needle unworked.

Work Rnds 17–31 of Silo chart, ending every even-numbered rnd as for Rnd 16 (moving marker).

SHAPE CROWN

Note: Change to dpns when there are too few sts to work comfortably on cir needle.

Work Rnds 32–56 of Silo chart, decreasing 6 sts on every even-numbered rnd as indicated—18 sts rem.

Break yarn, leaving a 6" (15 cm) tail. With tail threaded on tapestry needle, draw through rem sts, pull snug to tighten, and fasten off inside.

FINISHING

Weave in ends. Steam- or wet-block.

Silo Chart

Legend:

- □ knit
- • purl
- V sl 1 pwise wyb
- ⧅ LT
- ⧄ RT
- ⧄ work as RT for each rep around, except on last 2 sts of rnd. Sl 1 st to cn, hold in back, k1, slip beg of rnd marker, return st on cn to left needle unworked
- ▨ at the end of the rnd, remove beg of rnd marker, sl st(s) pwise wyb, replace marker for new beg of rnd
- ╱ k2tog
- □ pattern repeat

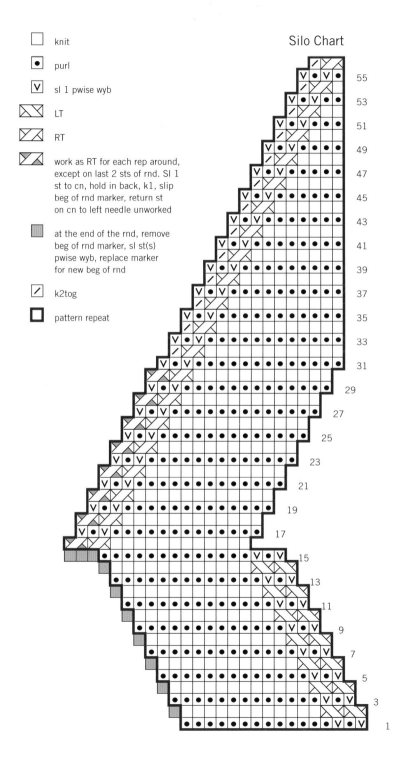

Row numbers (odd): 1, 3, 5, 7, 9, 11, 13, 15, 17, 19, 21, 23, 25, 27, 29, 31, 33, 35, 37, 39, 41, 43, 45, 47, 49, 51, 53, 55

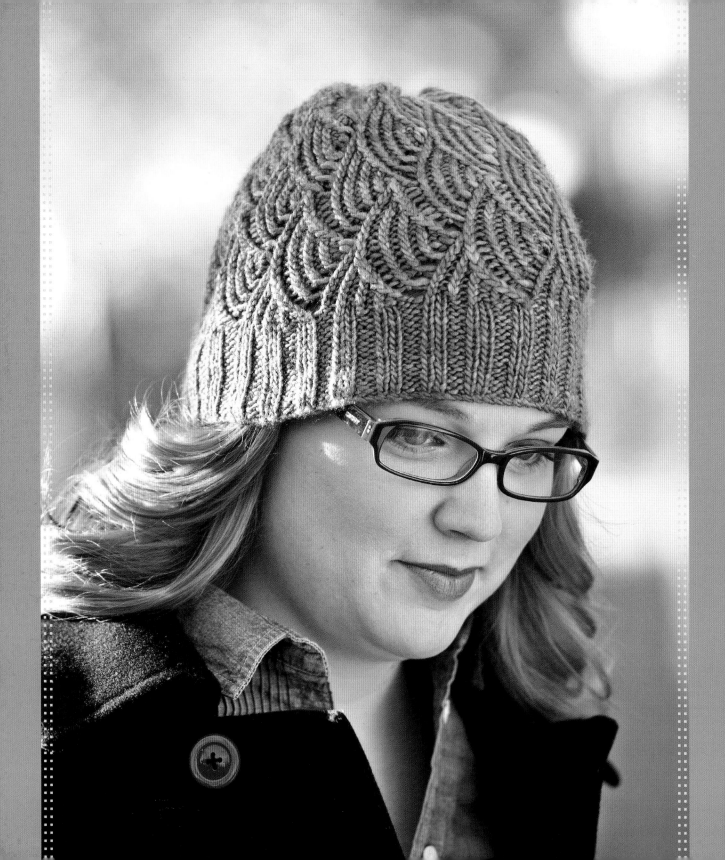

EVERDEEN BEANIE

BY TANIS GRAY

A beautiful allover scalloped lace pattern is the central focus of this pretty hat. A wide rib section keeps the hat snug against the head. The silk and wool–blend yarn provides crisp stitch definition and knits up into a soft, sturdy fabric that warms your head despite the lacy details.

materials

YARN

Light #3 (DK weight).
Shown here: Malabrigo Silky Merino (51% silk, 49% merino wool; 150 yd [137 m]/50 g): #414 cloudy sky, 1 hank.

NEEDLES

U.S. size 6 (4 mm): 16" (40 cm) circular (cir) and set of 4 double-pointed (dpn). Adjust needle size if necessary to obtain the correct gauge.

NOTIONS

Marker (m); tapestry needle.

GAUGE

22 sts and 28 rnds = 4" (10 cm) in lace patt; 22 sts and 32 rnds = 4" (10 cm) in k2/p2 ribbing.

FINISHED SIZE

21¾" (55 cm) circumference at brim; to fit 20–23" (51–58.5 cm) head circumference.

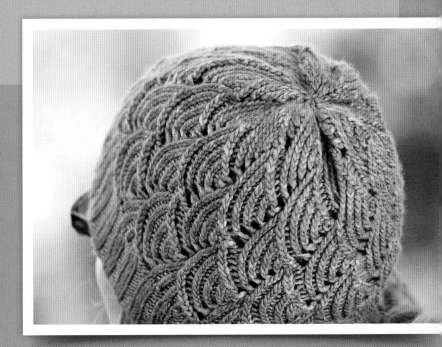

Stitch Guide

Fan Lace Pattern

(multiple of 10 sts)

Rnd 1: *Yo, knit 2 tog through back loops (k2tog tbl), [p1, k1 tbl] 4 times; rep from * to end.

Rnd 2: *Yo, p1, k2tog tbl, k1 tbl, [p1, k1 tbl] 3 times; rep from * to end.

Rnd 3: *Yo, k1 tbl, p1, k2tog tbl, [p1, k1 tbl] 3 times; rep from * to end.

Rnd 4: *Yo, p1, k1 tbl, p1, k2tog tbl, k1 tbl, [p1, k1 tbl] 2 times; rep from * to end.

Rnd 5: *Yo, [k1 tbl, p1] 2 times, k2tog tbl, [p1, k1 tbl] 2 times; rep from * to end.

Rnd 6: *Yo, [p1, k1 tbl] 2 times, p1, k2tog tbl, k1 tbl, p1, k1 tbl; rep from * to end.

Rnd 7: *Yo, [k1 tbl, p1] 3 times, k2tog tbl, p1, k1 tbl; rep from * to end.

Rnd 8: *Yo, [p1, k1 tbl] 3 times, p1, k2tog tbl, k1 tbl; rep from * to end.

Rnd 9: *Yo, [k1 tbl, p1] 4 times, k2tog tbl; rep from * to end.

Rnd 10: *K2tog tbl, [p1, k1 tbl] 4 times, yo; rep from * to end.

Rnd 11: *K2tog tbl, [k1 tbl, p1] 3 times, k1 tbl, yo, p1; rep from * to end.

Rnd 12: *K2tog tbl, [p1, k1 tbl] 3 times, yo, k1 tbl, p1; rep from * to end.

Rnd 13: *K2tog tbl, [k1 tbl, p1] 2 times, k1 tbl, yo, p1, k1 tbl, p1; rep from * to end.

Rnd 14: *K2tog tbl, [p1, k1 tbl] 2 times, yo, [k1 tbl, p1] 2 times; rep from * to end.

Rnd 15: *K2tog tbl, k1 tbl, p1, k1 tbl, yo, [p1, k1 tbl] 2 times, p1; rep from * to end.

Rnd 16: *K2tog tbl, p1, k1 tbl, yo, [k1 tbl, p1] 3 times; rep from * to end.

Rnd 17: *K2tog tbl, k1 tbl, yo, [p1, k1 tbl] 3 times, p1; rep from * to end.

Rnd 18: K2tog tbl, yo, *[k1 tbl, p1] 4 times, k2tog tbl, yo; rep from * to last 8 sts, [k1 tbl, p1] 3 times, k1 tbl, slip last st, remove m, replace slipped st to left needle and replace m.

BODY

Using cable method (see Glossary) and cir needle, CO 120 sts. Join for working in the rnd, being careful not to twist sts, and place marker (pm) for beg of rnd.

Rnd 1: *K2, p2; rep from * to end.

Rep the previous rnd until piece measures 1¾" (4.5 cm) from CO edge.

Work in Fan Lace patt until piece measures 8" (20.5 cm) from CO. *Note:* The position of the beg of the pattern shifts 1 st to the right at the end of Rnd 18. If you use markers between pattern repeats, the markers will need to be moved 1 st to the right at the end of every full chart rep.

SHAPE CROWN

Note: Switch to dpns when there are too few sts to work comfortably on cir needle.

Next rnd: *K2tog; rep from * to end—60 sts rem. Rep last rnd 2 more times—15 sts rem. Next Rnd: *K2tog; rep from * to last st, k1—8 sts rem. Break yarn, leaving an 8" (20.5 cm) tail. Thread tail onto tapestry needle, draw through rem sts, pull snug to tighten, and fasten off inside.

FINISHING

Weave in ends. Block as desired.

Fan Lace Chart

Legend:

- **O** yo
- k2tog tbl
- **•** purl
- k1 tbl
- **•** purl on all patt reps except on last st of rnd; slip last st, remove m, replace slipped st onto left needle, replace m
- □ pattern repeat

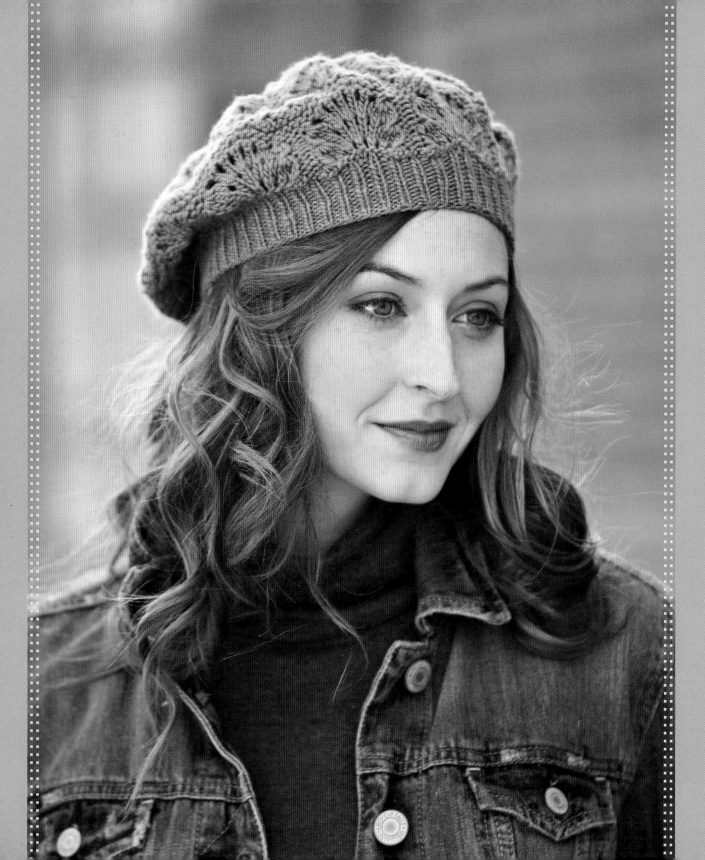

GREENERY BERET

BY MELISSA LABARRE

This beret uses a pretty variation of a classic feather-and-fan stitch. The soft ripples, created by increases and decreases in the pattern, complement hand-dyed and semisolid yarns and create an interesting shape. A ribbed band keeps this hat securely on the head.

materials

YARN
Light #3 (DK weight).
Shown here: Manos del Uruguay Silk Blend (70% merino, 30% silk; 150 yd [135 m]/50 g): #3204 lawn, 2 skeins.

NEEDLES
Ribbing—U.S. size 4 (3.5 mm): 16" (40 cm) circular (cir) needle. *Body—U.S. size 7 (4.5 mm):* 16" cir and set of 4 double-pointed (dpn). Adjust needle sizes if necessary to obtain the correct gauge.

NOTIONS
Stitch marker (m); tapestry needle.

GAUGE
23 sts and 36 rnds = 4" (10 cm) in k1, p1 ribbing, unstretched with smaller needles; 20 sts and 28 rnds = 4" (10 cm) in lace patt with larger needles.

FINISHED SIZE
17½" (44.5 cm) circumference at brim, unstretched; to fit 18–22" (45.5–56 cm) head circumference.

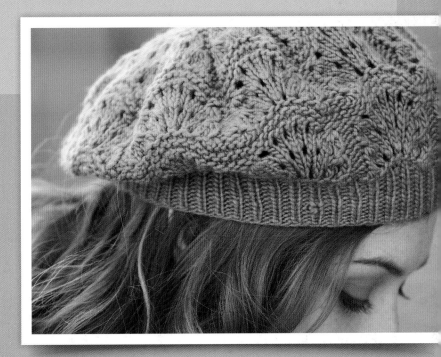

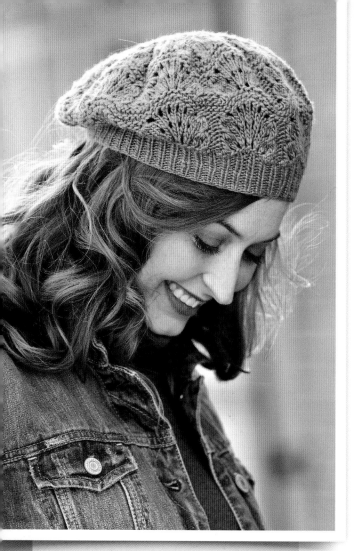

RIBBING

With smaller cir needle, CO 100 sts. Place marker (pm) for beg of rnd and join for working in the rnd, being careful not to twist sts.

Rnd 1: *K1, p1; rep from * to end.

Rep last rnd 12 more times.

Next rnd: (inc rnd): *K1, k1f&b; rep from * to end—150 sts.

Change to larger cir needle.

BODY

Work Lace Fan Chart 2 times.

SHAPE CROWN

Note: Change to dpns when there are too few sts to work comfortably on cir needle.

Work Decrease Chart—20 sts rem.

Next Rnd: (decrease rnd) *K2tog; rep from * to end—10 sts rem.

Rep the last rnd once more—5 sts rem.

Break yarn, leaving an 8" (20.5 cm) tail. With tail threaded on tapestry needle, draw through rem sts, pull snug to tighten, and fasten off inside.

FINISHING

Weave in ends. Dampen hat with water or steam and block stretched over a dinner plate to shape beret.

Decrease Chart

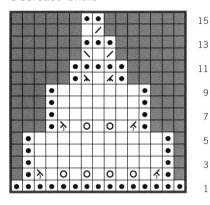

15

13

11

9

7

5

3

1

	knit
•	purl
O	yo
⤣	k4tog
⤦	sl 1, k3tog, psso
⤨	k3tog
⤥	sl 1, k2tog, psso
╱	k2tog
╲	ssk
☐	pattern repeat

Lace Fan Chart

13

11

9

7

5

3

1

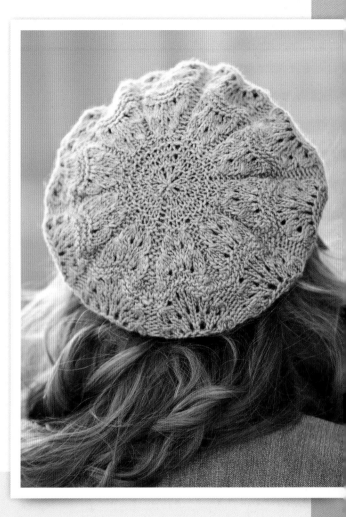

Tips and Techniques: USING A SMALLER NEEDLE FOR RIB AND BRIMS

Frequently in hat patterns, you will notice that the ribbed trims or brims are worked on a smaller needle than the body of the hat. Ribbed edges can get stretched out with wear, and using a smaller needle makes a denser fabric and helps to prevent this from happening. Hats that have brims as a design feature will often call for a smaller needle for working the brim. This stiffens the fabric and helps make a sturdier brim, without having to reinforce the fabric.

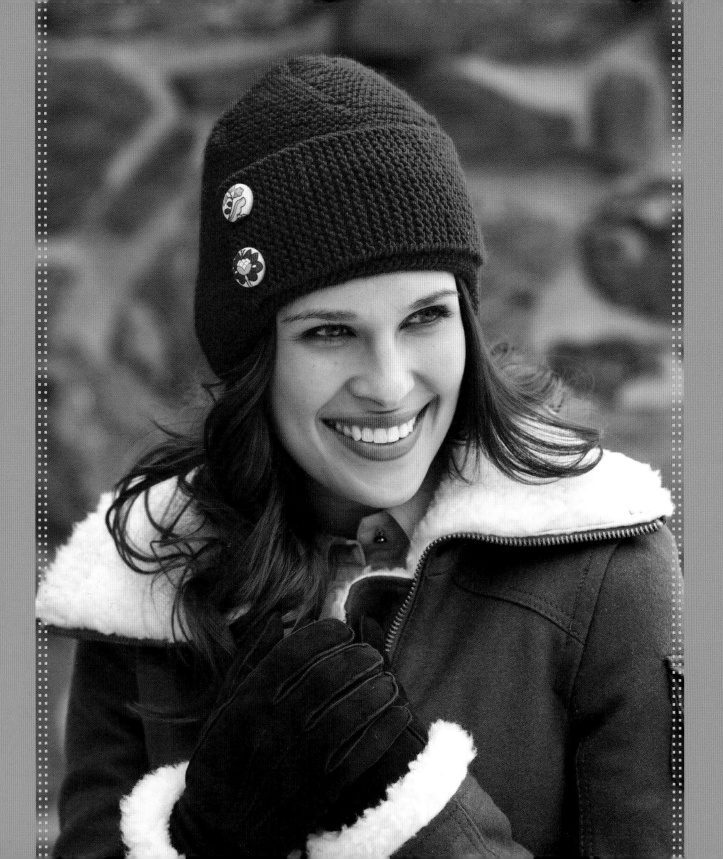

FLYER CAP

BY CECILY GLOWIK MACDONALD

The flyer cap is a fresh interpretation of an aviator-style hat. Worked from the crown down in garter stitch, the bottom shaping is achieved using simple short-rows. An additional band of garter stitch and button embellishment allows the knitter to personalize this whimsical winter cap.

materials

YARN
Medium #4 (worsted weight).
Shown here: Brown Sheep Lamb's Pride Worsted (85% wool, 15% mohair; 190 yd [174 m]/113 g): M145 spice, 1 skein.

NEEDLES
Hat—U.S. size 6 (4 mm): 16" (40 cm) circular (cir) and set of 4 or 5 double-pointed (dpns). *Buttonhole Band—U.S. size 7 (4.5 mm).* Adjust needle size if necessary to obtain the correct gauge.

NOTIONS
Marker (m); tapestry needle; two ⅞" (2 cm) buttons.

GAUGE
18 sts and 40 rows/rnds = 4" (10 cm) in garter stitch, unstretched, with smaller needles.

FINISHED SIZE
19" (48.5 cm) circumference at brim, unstretched; to fit 21½–22½" (54.5–57 cm) head circumference.

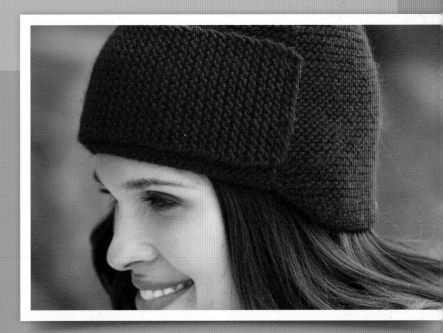

Stitch Guide

Garter Stitch in Rounds

Rnd 1: Knit all sts.

Rnd 2: Purl all sts.

Rep Rnds 1 and 2 for patt.

Garter Stitch in Rows

Knit all rows.

SHAPE CROWN

With dpns, CO 5 sts. Join for working in the rnd, being careful not to twist sts.

Next rnd: (inc rnd) *K1f&b, place marker (pm); rep from * to end—10 sts.

Next rnd: Purl.

Next rnd: (inc rnd) *Knit to 1 st before m, k1f&b, sl m; rep from * to end—5 sts increased.

Next rnd: Purl.

Rep last 2 rnds 14 more times—85 sts.

BODY

Change to smaller cir needle. Work even in garter st until piece measures 6" (15 cm) from CO, ending after a purl rnd.

BRIM

Next rnd: (inc rnd) *K4, k1f&b; rep from * to end—102 sts.

Next rnd: Purl.

Work short-rows (see Glossary) as foll:

Next row: (RS) K64, wrap & turn (w&t).

Next row: (WS) Knit to 1 st before m, w&t.

Next row: Knit to 1 sts before wrapped st, w&t.

Rep the last row 9 more times, ending after a WS row—6 sts have been wrapped on each side.

Next rnd: Knit to end.

Work even in garter st for 3 rnds.

Next rnd: BO all sts loosely knitwise (kwise).

BUTTONHOLE BAND

With larger needles, CO 16 sts. Work even in garter st until piece measures 7¾" (19.5 cm), ending after a WS row.

Buttonhole row: (RS) K3, BO 2, knit to last 5 sts, BO 2, k3.

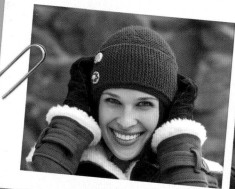
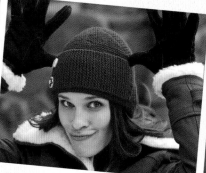
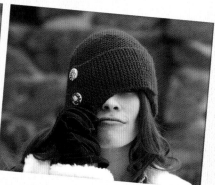

Next row: Knit and *at the same time* CO 2 sts over each set of BO sts.

Work even in garter st until piece measures ½" (1.3 cm) from buttonhole row, ending after a WS row.

BO all sts kwise.

FINISHING

Block pieces. Lay hat flat so short-rows are in the back, and section without short-rows is centered in the front. Position buttonhole band on hat aligning buttonholes to the left and CO edge to the right edge of section without short-rows (see photo on page 27) ½" (1.3 cm) above edge of brim. Sew CO edge to hat and sew buttons to hat opposite buttonholes. (When buttoned, band will pull slightly to open up garter st rows.)

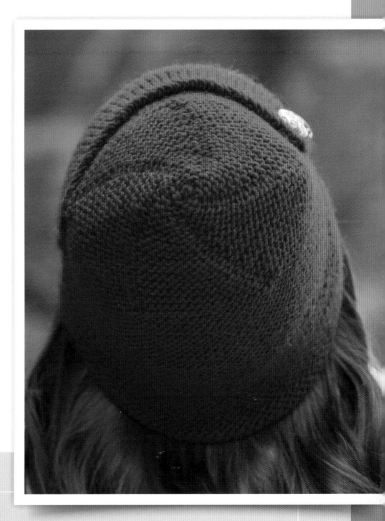

Tips and Techniques: SWATCHING TIPS

The only way to ensure your finished piece will be the right size is by first knitting a swatch. This will help you determine what needle size is needed to get the recommended gauge. To knit a good swatch, cast on at least 5 more stitches than the recommended stitch gauge over 4 inches. When knitting a swatch flat, edge stitches can curl in and do not give an accurate measurement, so begin by measuring a couple of stitches in from the edge. If your project is knit in the round, knit your swatch in the round since a knitter's gauge can vary significantly between being knit flat or in the round.

Wash and block your finished swatch in the same manner you intend to treat your finished object. This way you'll be able to tell how the stitches will behave when steamed/wet-blocked and then dried.

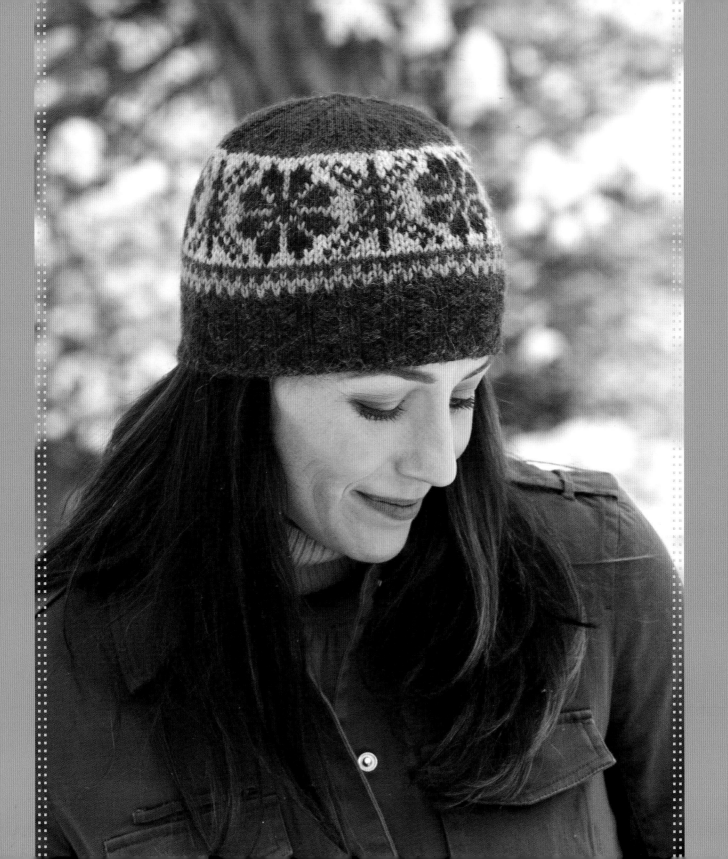

CHROMA CAP

BY MARY JANE MUCKLESTONE

materials

YARN

Medium #4 (worsted weight).
Shown here: Berrocco Ultra Alpaca
(50% alpaca, 50% wool; 215 yd
[198 m]/100 g): #62171 berry pie mix (A),
#6277 peat mix (B), #6224 steel blue (C),
#6206 light gray (D), #6282 boysenberry
mix (E), #6217 tupelo (F), #6234
cardinal (G), 1 skein each.

NEEDLES

Brim—U.S. size 6 (4 mm): 16" (40 cm)
circular (cir). *Body—U.S. size 7 (4.5 mm):*
16" (40 cm) cir and set of 4 double-
pointed (dpn). Adjust needle size if
necessary to obtain the correct gauge.

NOTIONS

Marker (m); tapestry needle.

GAUGE

21 sts and 24 rnds = 4" [10 cm] in
Checkerboard edging; 24 sts and 24 rnds
= 2" [10 cm] in Fair Isle pattern on larger
needle.

FINISHED SIZE

16 (18¼, 20½)" (40.5 [46.5, 52] cm)
circumference at brim; to fit 14¾–16¾
(17–19, 19¼–21¼)" (37.5–42.5 [43–48,
49–54] cm) head circumference.
Hat shown in 18¼" (46.5 cm) size.

I originally made this hat for my friend Trevor, an artist who lives in Fort Green, Brooklyn. I like the combination of the geometric checkerboard edging and the floral OXO border pattern that references the color-work knitting traditions of Norway, Peru, Scotland, and the Baltics. In this instance, the X has a starlike quality.

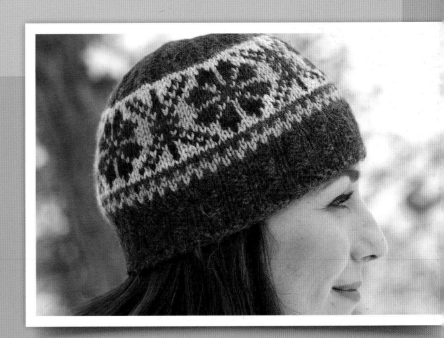

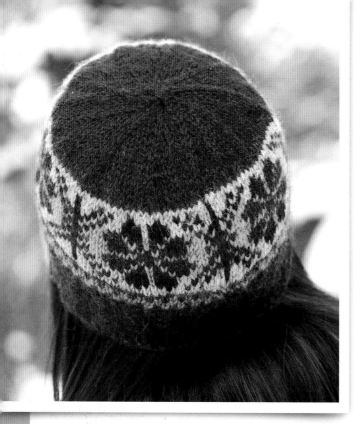

SHAPE CROWN

Note: Change to dpns when there are too few sts to work comfortably on cir needle.

Rnd 1: (dec rnd) With A, *k8 (9, 10), k2tog; rep from * to end—90 (100, 110) sts rem.

Rnds 2, 4, 6, 8, and 10: Knit.

Rnd 3: (dec rnd) *K3, k2tog; rep from * to end—72 (80, 88) sts rem.

Rnd 5: (dec rnd) *K6, k2tog; rep from * to end—63 (70, 77) sts rem.

Rnd 7: (dec rnd) *K5, k2tog; rep from * to end—54 (60, 66) sts rem.

Rnd 9: (dec rnd) *K1, k2tog; rep from * to end—36 (40, 44) sts rem.

Rnd 11: (dec rnd) *K2, k2tog; rep from * to end—27 (30, 33) sts rem.

Rnd 12: (dec rnd) *K1, k2tog; rep from * to end—18 (20, 22) sts rem.

Rnd 13: (dec rnd) *K2tog; rep from * to end—9 (10, 11) sts rem.

Rnd 14: (dec rnd) K1 (0, 1), *k2tog; rep from * to end—5 (5, 6) sts rem.

Break yarn, leaving an 8" (20.5 cm) tail. Draw through rem sts, pull snug to tighten, and fasten off inside.

FINISHING

Weave in ends. Wash gently in mild detergent, carefully pressing out moisture with a towel. Shape and dry over an inflated balloon away from heat.

BRIM

With B and smaller cir needle, CO 84 (96, 108) sts. Place marker (pm) for beg of rnd and join for working in the rnd, being careful not to twist sts.

Next rnd: *K2, p2; rep from * to end.

Work Rnds 1–15 of Checkerboard Chart.

BODY

Next rnd: (inc rnd) With larger needle and B, k9 (5, 9), M1 (see Glossary), *k5 (7, 9), M1; rep from * to end—100 (110, 120) sts.

Work Rnds 1–21 of corresponding size Fair Isle Chart.

Note: If desired, hat can be lengthened after Fair Isle patt is completed by working even with A in St st.

- ▨ Berry Pie (A) knit
- ▣ Berry Pie (A) purl
- ▣ Peat Mix (B) knit
- ▣ Peat Mix (B) purl
- − Steel Blue (C) knit
- + Light Gray (D) knit
- △ Boysenberry Mix (E) knit
- = Tupelo (F) knit
- ✕ Cardinal (G) knit
- ☐ pattern repeat for 16" size
- ☐ pattern repeat for 18¼" size
- ☐ pattern repeat for 20½" size

Checkerboard Chart

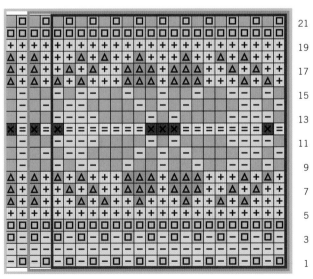

Fair Isle Chart

SEMOLINA EARFLAP HAT

BY CARRIE BOSTICK HOGE

This cheery cabled hat brightens even the grayest days. The allover cables are easy to work and create a dense fabric that provides plenty of warmth. The cozy earflaps add more protection from the elements.

materials

YARN
Medium #4 (worsted weight).
Shown here: Quince & Co. Lark (100% American wool; 134 yd [123 m]/50 g): #125 Carrie's yellow, 2 skeins.

NEEDLES
U.S. size 7 (4.5 mm): 16" (40 cm) circular (cir) and set of 4 or 5 double-pointed (dpn). Adjust needle size if necessary to obtain the correct gauge.

NOTIONS
Marker (m); cable needle (cn) or extra dpn; waste yarn or stitch holder; U.S. size H/8 (5 mm) crochet hook; tapestry needle.

GAUGE
27 sts and 32 rnds = 4" (10 cm) in Semolina Cable patt, unstretched.

FINISHED SIZE
21¼" (54 cm) circumference at brim, unstretched; to fit 22–23" (56–58.5 cm) head circumference.

Stitch Guide

Semolina Cable Pattern

(multiple of 9 sts)

Rnd 1: *K8, p1; rep from * to end.

Rnd 2: *Sl 2 sts to cn and hold in *back,* k2, k2 from cn, k4, p1; rep from * to end.

Rnds 3–5: Rep Rnd 1.

Rnd 6: Rep Rnd 2.

Rnd 7: Rep Rnd 1.

Rnd 8: *K4, sl 2 sts to cn and hold in *front,* k2, k2 from cn, p1; rep from * to end.

Rnds 9–11: Rep Rnd 1.

Rnd 12: Rep Rnd 8.

Rep Rnds 1–12 for Semolina Cable patt.

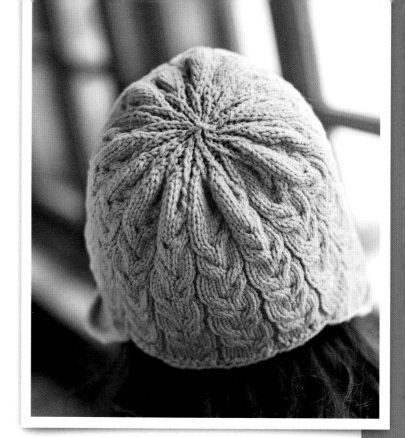

EARFLAPS (MAKE 2)

CO 4 sts.

Rows 1, 3, 5: (WS) Purl.

Rows 2, 4, 6: (inc row) K1, M1 (see Glossary), knit to last st, M1, k1—10 sts after Row 6.

Row 7: Purl.

Row 8: (inc row) K1, M1P (see Glossary), knit to last st, M1P, k1—12 sts.

Row 9: P1, k1, purl to last 2 sts, k1, p1.

Row 10: (inc row) K1, M1, p1, k4, sl 2 sts to cn and hold in front, k2, k2 from cn, p1, M1, k1—14 sts.

Row 11: P2, k1, p8, k1, p2.

Row 12: (inc row) K1, M1, k1, p1, k8, p1, k1, M1, k1—16 sts.

Row 13: P3, k1, p8, k1, p3.

Row 14: (inc row) K1, M1, k2, p1, k4, sl 2 sts to cn and hold in front, k2, k2 from cn, p1, k2, M1, k1—18 sts.

Row 15: P4, k1, p8, k1, p4.

Row 16: (inc row) K1, M1, k3, p1, sl 2 sts to cn and hold in back, k2, k2 from cn, k4, p1, k3, M1, k1—20 sts.

Row 17: P5, k1, p8, k1, p5.

Row 18: (inc row) K1, M1, k4, p1, k8, p1, k4, M1, k1—22 sts.

Row 19: P6, k1, p8, k1, p6.

Row 20: (inc row) K1, M1, k5, p1, sl 2 sts to cn and hold in back, k2, k2 from cn, k4, p1, k5, M1, k1—24 sts.

Cable Chart

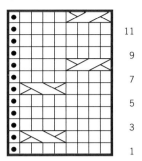

- ☐ knit on RS, purl on WS
- ⊡ purl on RS, knit on WS
- ⧄ sl 2 sts onto cn, hold in front; k2; k2 from cn
- ⧅ sl 2 sts onto cn, hold in back; k2; k2 from cn
- ☐ pattern repeat

Row 21: P7, k1, p8, k1, p7.

Row 22: (inc row) K1, M1, k6, p1, k4, sl 2 sts to cn and hold in front, k2, k2 from cn, p1, k6, M1, k1—26 sts.

Row 23: P8, k1, p8, k1, p8.

Row 24: (inc row) K1, M1, k7, p1, k8, p1, k7, M1, k1—28 sts.

Row 25: P9, k1, p8, k1, p9.

Slip sts to st holder or waste yarn and set aside. Break yarn.

BRIM

With cir needle and using the backward loop method (see Glossary), CO 35 sts for back; with RS of one earflap facing, work as foll: p1, k8, p1, k4, sl 2 sts to cn and hold in front, k2, k2 from cn, p1, k8, p1; CO 53 sts for front; with RS of other earflap facing, work as foll: p1, k8, p1, k4, sl 2 sts to cn and hold in front, k2, k2 from cn, p1, k8, p1—144 sts.

Join for working in the rnd, being careful not to twist sts. Place marker (pm) for beg of rnd.

BEGIN SEMOLINA CABLE PATTERN

Work in Semolina Cable patt for 43 rnds, ending with Rnd 7 (piece measures 5½" (14 cm) from beg of brim).

SHAPE CROWN

Note: Switch to dpns when there are too few sts to work comfortably on cir needle.

Rnd 1: (dec rnd) *Ssk, k4, k2tog, p1; rep from * to end—112 sts rem.

Rnd 2: *K6, p1; rep from * to end.

Rnd 3: (dec rnd) *Ssk, k2, k2tog, p1; rep from * to end—80 sts rem.

Rnd 4: *K4, p1; rep from * to end.

Rnd 5: (dec rnd) *Ssk, k2tog, p1; rep from * to end—48 sts rem.

Rnd 6: *K2, p1; rep from * to end.

Rnd 7: (dec rnd) *Ssk, p1; rep from * to end—32 sts rem.

Rnd 8: *K1, p1; rep from * to end.

Rnd 9: (dec rnd) *Ssk; rep from * to end—16 sts rem.

Rnd 10: Knit.

Rnds 11–12: Rep Rnds 9 and 10—8 sts rem.

Rnd 13: Rep Rnd 9—4 sts rem.

Break yarn, leaving an 8" (20.5 cm) tail. Draw through rem sts, pull snug to tighten, and fasten off inside.

FINISHING

Beg at center back of brim, work single crochet edging (see Glossary) around lower edge of hat and earflaps. Break yarn. Weave in ends. Block if desired.

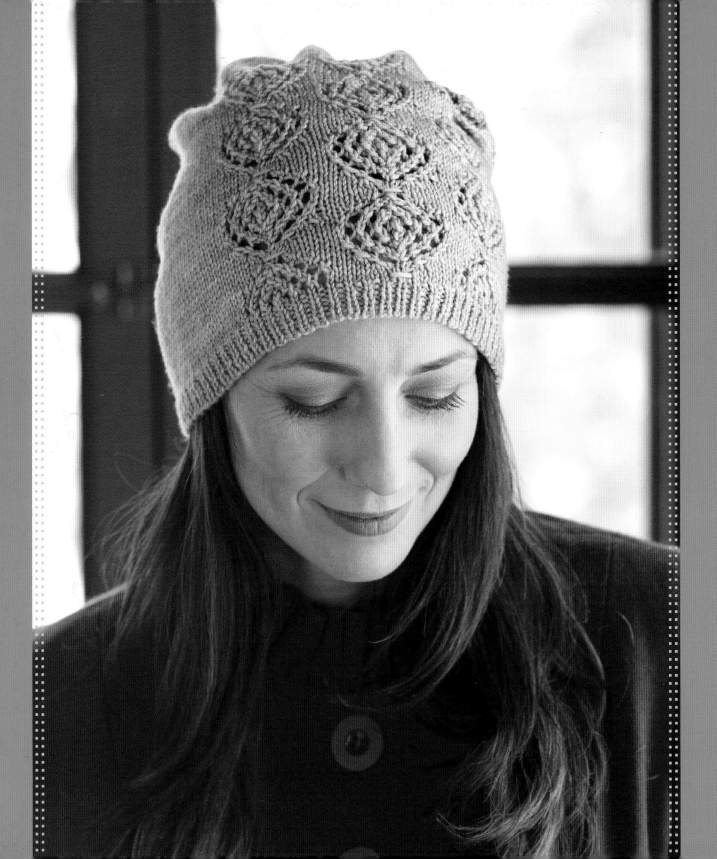

TOPIARY BEANIE

BY JENNIFER LANG-MACKENZIE

A pretty circular lace pattern is front and center in this lightweight and perfectly slouchy hat. The stockinette-stitch background makes the delicate lace details pop, while showcasing the hand-dyed semisolid yarn.

materials

YARN
Light #3 (DK weight). *Shown here:* Madelinetosh Pashmina (75% superwash merino, 15% silk, 10% cashmere; 360 yd [329 m]/117 g): silverfox, 1 skein.

NEEDLES
Ribbing—U.S. size 3 (3.25 mm): 16" (40 cm) circular (cir). *Body—U.S. size 5 (3.75 mm):* 16" (40 cm) cir and set of 4 double-pointed (dpn). Adjust needle sizes if necessary to obtain the correct gauge.

GAUGE
24 sts and 36 rnds = 4" (10 cm) in St st on larger needles.

FINISHED SIZES
18 (22)" (45.5 [56] cm) circumference at brim; to fit 18–22 (22–26)" (45.5–56 [56–66] cm) head circumference. Shown in 22" (56 cm) size.

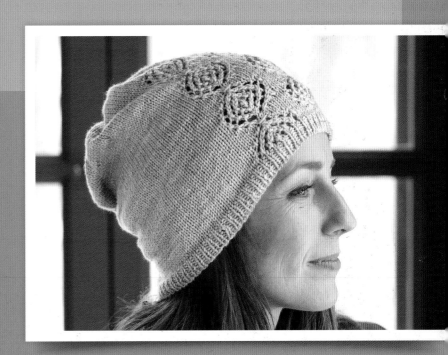

RIBBING

With smaller cir needle, use the tubular method (see Glossary) to CO 108 (132) sts. Place marker (pm) and join for working in the rnd, being careful not to twist sts.

Rnd 1: *K1, p1; rep from * to end.

Rep last rnd until piece measures ¾" (2 cm).

BODY

Change to larger cir needle.

Next rnd: K1, [sl 1, k1] 4 times, k29 (41), pm, k41, pm, knit to end of rnd.

Next rnd: (set-up rnd) work 9 sts in Slip Chart, knit to m, sl m, work 41 sts in Lace Chart, sl m, knit to end.

Cont as set, working Rnds 1–16 of Lace Chart 3 times, ending after rnd 16. Work Rnds 17–46 of Lace Chart 1 time.

CROWN SHAPING

Rnd 1: Knit.

Rnd 2: *K2tog; rep from * to end—54 (66) sts rem.

Rnd 3: Knit.

Rnd 4: *K2tog; rep from * to end—27 (33) sts rem.

Rnd 5: Knit.

Rnd 6: *K2tog; rep from * to last st, k1—14 (17) sts rem.

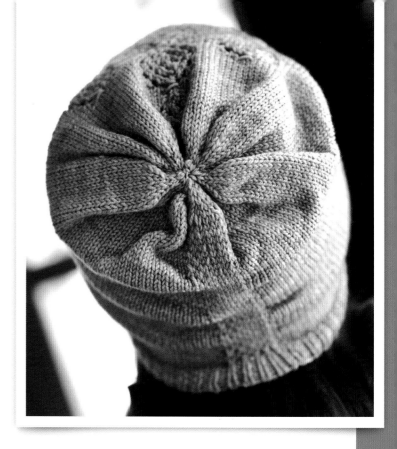

Break yarn, leaving an 8" (20.5 cm) tail. With tail threaded on tapestry needle, draw through rem sts, pull snug to tighten, and fasten off inside.

FINISHING

Weave in ends. Block lace open, avoiding the ribbed edge.

Tips and Techniques: TWISTED STITCHES

There are many stitch patterns in which a "twisted" stitch (k tb1) is used. To twist a stitch, you knit through the back loop rather than through the front loop. This literally adds a twist to the bottom of the stitch and makes it rise up off the fabric slightly higher, adding a new texture.

Lace Chart

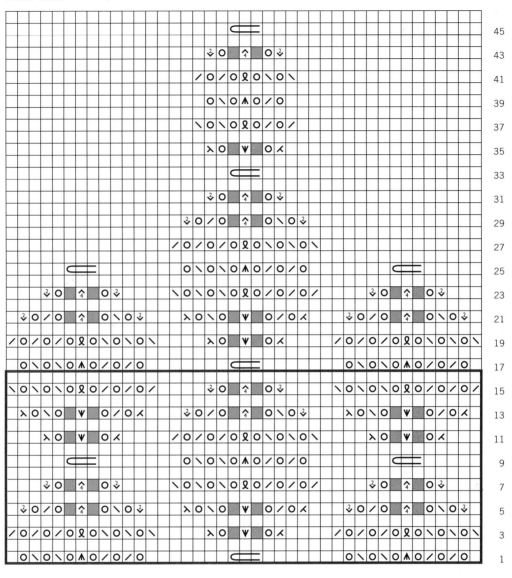

☐	knit
Ⅴ	sl 1 pwise wyb
ℓ	k tbl
O	yo
╱	k2tog
╲	ssk

⋀	sl2-k1-p2sso
⌐	sl 3 pwise wyf, bring yarn to back, return slipped sts to left needle, k3
⬇	knit 1 st in front and back of next st
⬆	sl 1-k4tog-psso
Ⅴ	knit 1 st in front, back, front of next st

⋋	k3tog
⋌	sssk
▨	no stitch
☐	pattern repeat

Slip Chart

	Ⅴ	
	Ⅴ	
Ⅴ		Ⅴ
Ⅴ		Ⅴ

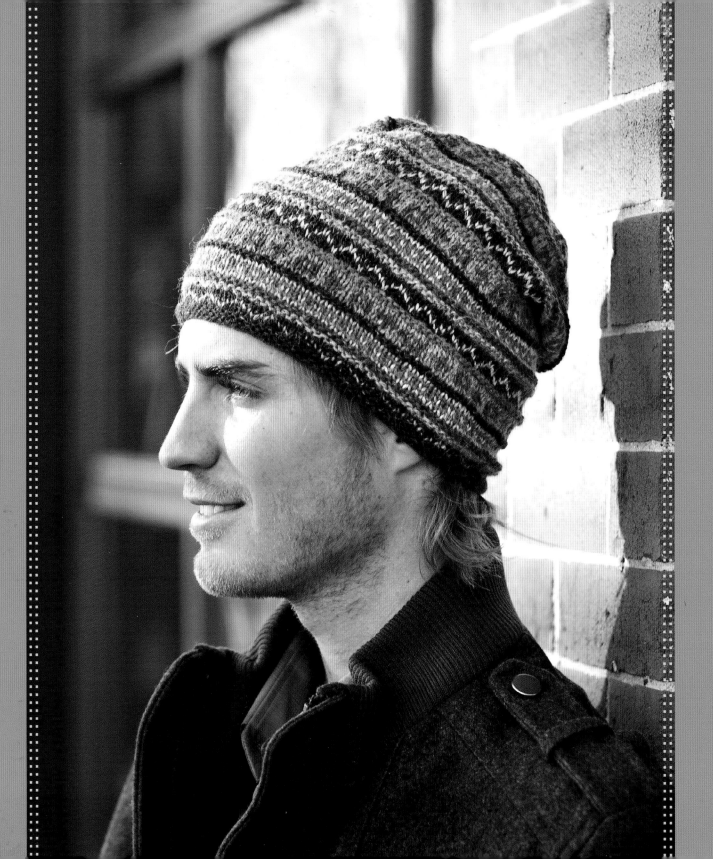

HUED TOQUE

BY GUDRUN JOHNSTON

The small bands of color in this slouchy hat make for a richly patterned piece that is suitable for a woman or a man. The design provides a foundation that allows you to easily devise a personalized color palette. The quick color changes make it an exciting and addictive knitting technique.

materials

YARN
Light #3 (DK weight).
Shown here: Rowan Felted Tweed DK (50% merino wool, 25% alpaca, 25% viscose; 191 yd [175 m]/50 g): #170 seafarer (A), #165 scree (B), #161 avocado (C), #158 pine (D), and #152 watery (E), 1 ball each.

NEEDLES
Brim—U.S. size 4 (3.5 mm): 16" (40 cm) circular (cir). *Body—U.S. size 5 (3.75 mm):* 16" (40 cm) cir and set of 4 double-pointed (dpn). Adjust needle sizes if necessary to obtain the correct gauge.

NOTIONS
Marker (m); tapestry needle.

GAUGE
26 sts and 36 rnds = 4" (10 cm) in Peerie pattern with larger needles.

FINISHED SIZE
17½" (44.5 cm) circumference at brim; to fit 18–22" (45.5–56 cm) head circumference.

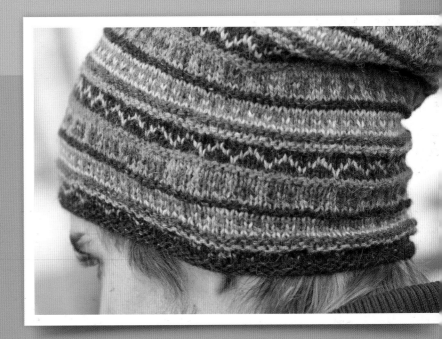

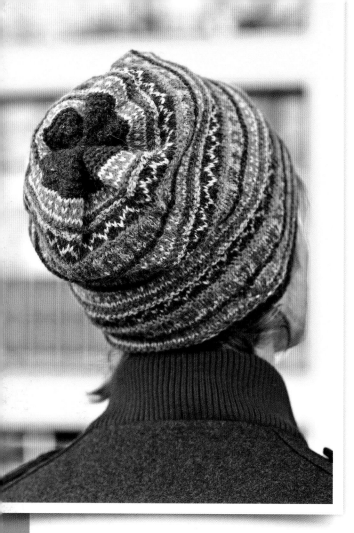

Peerie Chart

23	• purl in same color as previous rnd
21	▬ Seafarer (A) knit
19	△ Scree (B) knit
17	▣ Avocado (C) knit
15	— Pine (D) knit
13	▢ Watery (E) knit
11	▢ pattern repeat
9	
7	
5	
3	
1	

Tips and Techniques: CARRYING YARNS IN FAIR ISLE

When working a piece in Fair Isle, or Peerie pattern as used here, it is very important to make sure that your floats (the strands formed by the nonworking yarn that is carried behind the stitches) aren't too long. When a color needs to be carried for more than four stitches, it is important to wrap the color being carried with the working color every few stitches. This prevents your floats from being too tight and pulling the stitches, or being too loose and easy to snag.

BRIM

With A and smaller needles, CO 96 sts. Place marker (pm) for beg of rnd and join for working in the rnd, being careful not to twist sts. Purl 1 rnd. Knit 1 rnd. Purl 1 rnd.

BODY

Change to larger cir needle. Work Rnds 1–7 of Peerie Chart.

Next rnd: (inc rnd) With D, *k5, k1f&b; rep from * to end—112 sts.

Work Rnds 9–16 of Peerie Chart.

Next rnd: (inc rnd) With C, *k6, k1f&b; rep from * to end—128 sts.

Work Rnds 18–23 of Peerie Chart once, then work Rnds 1–23 two more times, then work Rnds 1–16 once more.

SHAPE CROWN

Note: Change to dpns when there are too few sts to work comfortably on cir needle.

Rnd 1: With A, *k6, k2tog; rep from * to end—112 sts rem.

Rnds 2, 4, 6, and 8: Purl.

Rnd 3: *K5, k2tog; rep from * to end—96 sts rem.

Rnd 5: *K4, k2tog; rep from * to end—80 sts rem.

Rnd 7: *K2tog; rep from * to end—40 sts rem.

Rnd 9: *K2tog; rep from * to end—20 sts rem.

Break yarn, leaving an 8" (20.5 cm) tail. With tail threaded on tapestry needle, draw through rem sts, pull snug to tighten, and fasten off inside.

FINISHING

Weave in ends. Soak hat in gentle wool wash and block.

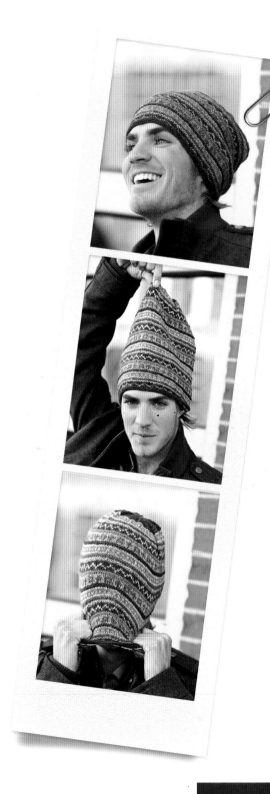

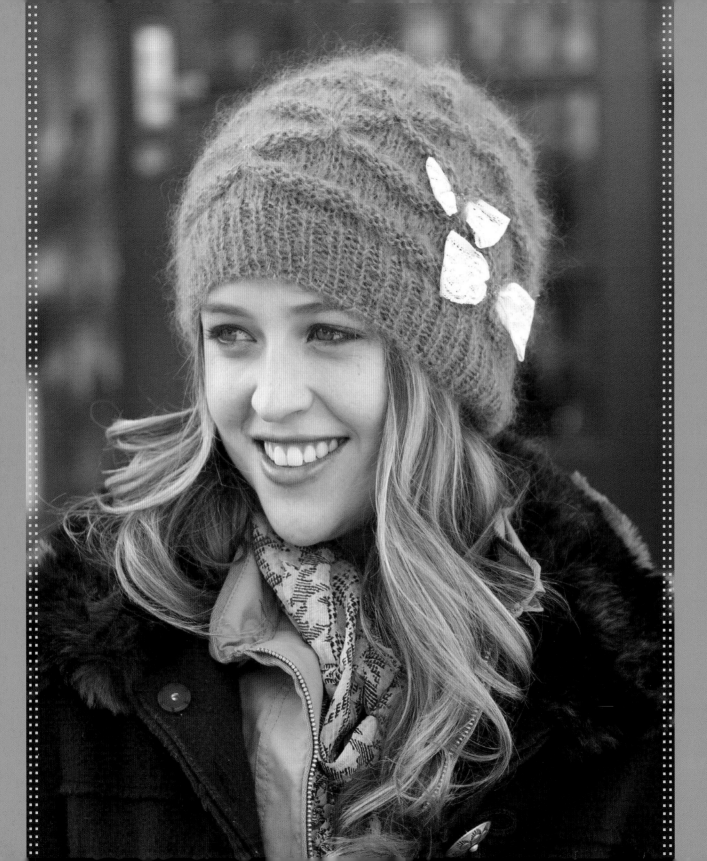

RIPPLE HAT

BY MELISSA WEHRLE

A beautiful yarn and a textured-stitch pattern give this hat an allover luxurious look and feel (and a lovely halo). Embellish the hat with a few bows and beads for a romantic detail.

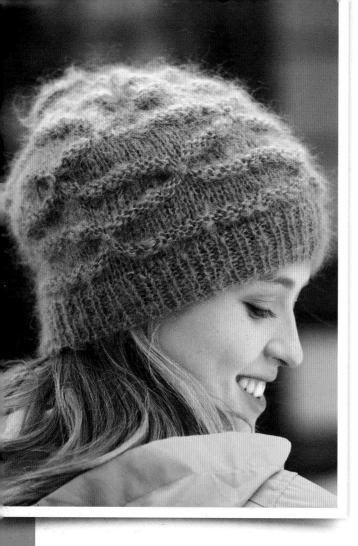

Textured Stripe Pattern

Rnds 1–3: Purl.

Rnd 4: *Pick up and knit 1 st 4 rows below with left needle and knit st tog with next stitch on left needle; rep from * to end.

Rnds 5–10: Knit.

Rep Rnds 1–10 for pattern.

RIBBING
With smaller cir needle, CO 76 (86, 93) sts. Place marker (pm) for beg of rnd and join for working in the rnd, being careful not to twist sts.

Rnd 1: *K1, p1; rep from * to end.

Rep the last rnd until hat measures 1½" (4 cm).

BODY
Change to larger cir needle.

Knit 4 rnds, then work 44 (54, 54) rnds in Textured Stripe patt, ending with Rnd 4.

Knit 3 rnds. (piece will measure about 7½ (8¾, 8¾)" (19 [22, 22] cm) from beg after gathered finishing)

Next rnd: (eyelet rnd) *K2tog, yo, k3; rep from * 13 (15, 17) more times, yo, k2tog, knit to end of rnd.

Knit 2 rnds.

BO all sts loosely.

Note
Pattern is worked as "stripes" first. Then raised bands are sewn together to make pattern.

TIE

With dpn, CO 3 sts. Work I-cord (see Glossary) until piece measures 25 (26, 27)" (63.5 [66, 68.5] cm). BO sts. See Optional Hat Embellishment below, for attaching tie.

FINISHING

Weave in ends. Block. With yarn and tapestry needle, gather together and sew the first and second raised bands 5 times evenly around the hat. Gather and sew the second and third raised bands 5 times around the hat, working gathers in a different location than before; cont for each raised band, or work gathers randomly as desired.

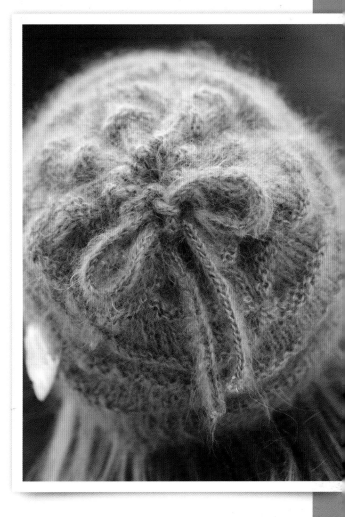

Tips and Techniques: OPTIONAL HAT EMBELLISHMENT

Embellishment can be a fun way of personalizing your knits. Cut one 5½" (14 cm) and one 7¾" (19.5 cm) length of lace ribbon. Fold each end toward the center to make a bow shape and insert each bow behind a gather. Tack down bow, making sure to catch all layers of yarn and ribbon. Use beading needle and thread to embellish 9 beads in the middle of each bow and 6 beads at each end of the tie. Thread tie through eyelets at top. Pull tightly and tie into a bow.

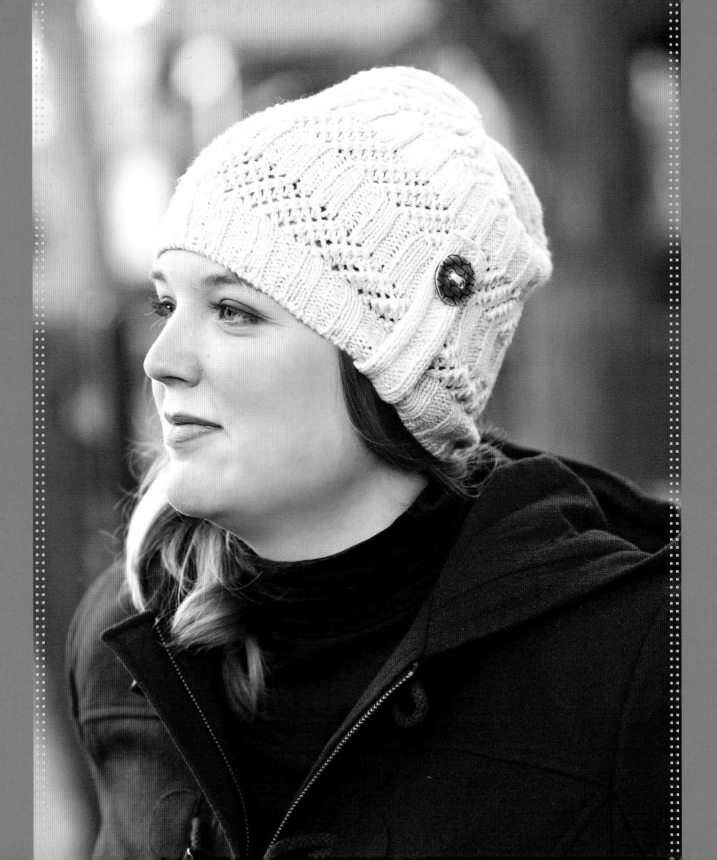

UNION LONG BEANIE

BY CONNIE CHANG CHINCHIO

Alternating ribbed bands and a simple lace pattern come together to form this lovely textured hat. Knit to longer-than-usual length, it has a sassy bit of slouch. The button tab pulls the hat together with a little scrunch, and the button detail adds a pop of color.

materials

YARN
Light #3 (DK weight).
Shown here: Bijou Basin Himalayan Trail (75% yak, 25% merino; 200 yd [183 m]/2 oz): natural, 2 skeins.

NEEDLES
U.S. size 3 (3.25 mm): 16" (40 cm) circular (cir) and set of 4 double-pointed (dpn). Adjust needle size if necessary to obtain the correct gauge.

NOTIONS
1⅛" (3 cm) button; tapestry needle.

GAUGE
26 sts and 32 rnds = 4" (10 cm) in k3, p3 ribbing.

FINISHED SIZE
18½" (47 cm) circumference; to fit 19–24" (48.5–61 cm) head circumference.

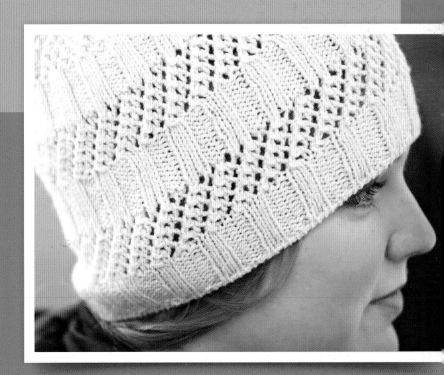

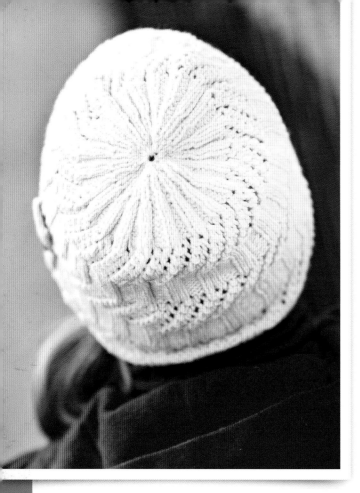

BODY

With cir needle and using tubular method (see Glossary), CO 120 sts. Place marker (pm) and join for working in the rnd, being careful not to twist sts.

Rnd 1: *K3, p3; rep from * to end.

Rep last rnd until piece measures 1½" (4 cm).

Work Cellular St for 1½" (4 cm), ending after Rnd 2.

Next rnd: (inc rnd) *K10, m1; rep from * to end—132 sts.

*Work [k3, p3] rib for 1½" (4 cm). Work Cellular St for 1½" (4 cm), ending after Rnd 2.

Rep from * once more; hat measures 9" (23 cm).

Work [k3, p3] rib for 2 rnds.

SHAPE CROWN

Note: Change to dpns when there are too few sts to work comfortably on cir needle.

Rnd 1: (dec rnd) *K2tog, k1, p3; rep from * to end—110 sts rem.

Rnds 2, 3: *K2, p3; rep from * to end.

Rnd 4: (dec rnd) *K2, p2tog, p1; rep from * to end—88 sts rem.

Rnds 5, 6: *K2, p2; rep from * to end.

Rnd 7: (dec rnd) *K2tog, p2; rep from * to end—66 sts rem.

Rnds 8, 9: *K1, p2; rep from * to end.

Rnd 10: (dec rnd) *K1, p2tog; rep from * to end—44 sts rem.

Rnds 11, 12: *K1, p1; rep from * to end.

Rnd 13: (dec rnd) *K2tog; rep from * to end—22 sts rem.

Break yarn, leaving an 8" (20.5 cm) tail. With tail threaded on tapestry needle, draw through rem sts, pull snug to tighten, and fasten off inside.

Stitch Guide

Cellular Stitch

(multiple of 4 sts)

Rnd 1: *Yo, k1, yo, sl 1-k2tog-psso; rep from * to end.

Rnd 2: Knit.

TAB

With dpn, CO 9 sts. Do not join; work back and forth in rows.

Row 1: (RS) K3, p3, k3.

Row 2: (WS) P3, k3, p3.

Rep Rows 1 and 2 until tab measures 3½" (9 cm) ending with a WS row.

Next row: (RS) K3, work 3 st buttonhole, k3.

Cont to work in rib until tab measures 4½" (11.5 cm). BO all sts in rib.

FINISHING

Block hat and tab if desired.

Tuck CO edge of tab under brim for 1" (2.5 cm) and sew in place to WS with yarn. Sew button to body of hat on RS, 3" above where the tab is joined to the hat. Insert button into buttonhole and tack tab in place if desired.

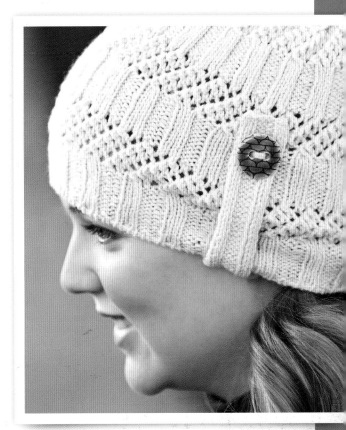

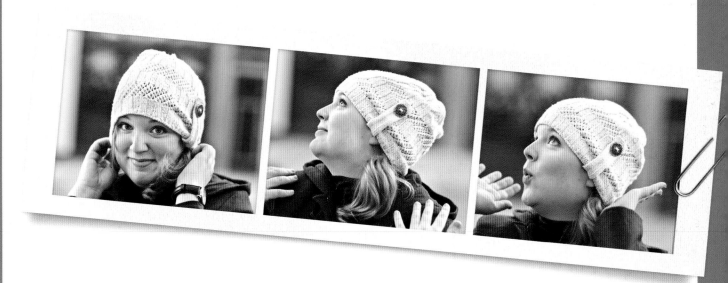

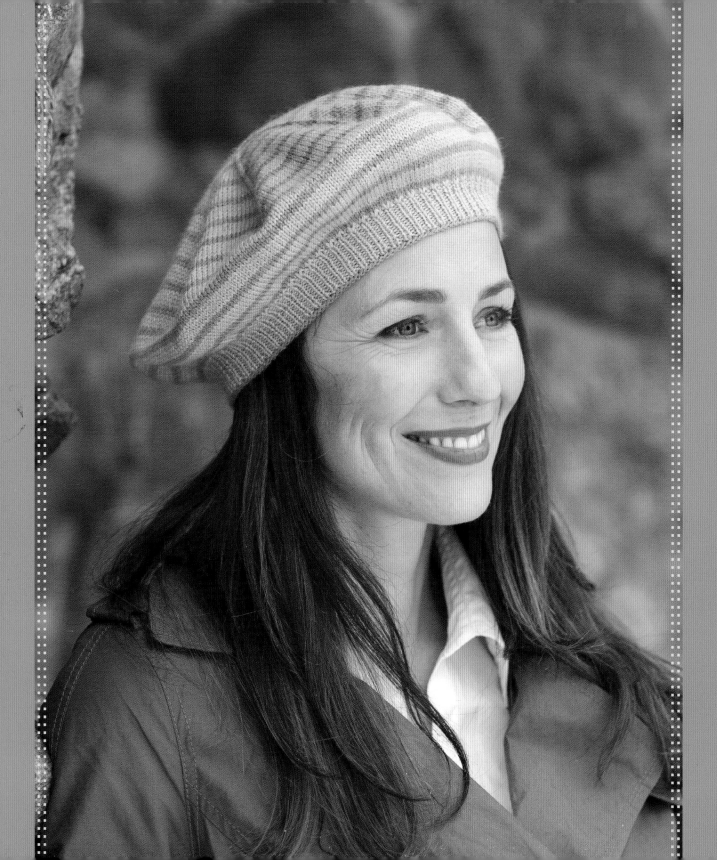

TRELLIS BERET

BY COURTNEY KELLEY

This beret has classic style, thanks to its face-flattering shape. Using a yarn with a little drape accentuates the slouched look. Make an impact by choosing unconventional color pairings or keep it simple with neutral hues appropriate for everyday wear.

materials

YARN
Fine #1 (fingering weight).
Shown here: The Fibre Company Canopy Fingering (50% alpaca, 30% merino, 20% viscose from bamboo; 200 yd [183 m]/50 g): fern (MC) brazil nut (CC), 1 skein each.

NEEDLES
Ribbing—U.S. size 1 (2.25 m): 16" (40 cm) circular (cir). *Body—U.S. size 2 (2.75 mm):* 16" (40 cm) cir and set of 4 double-pointed (dpn). Adjust needle sizes if necessary to obtain the correct gauge.

NOTIONS
Marker (m); tapestry needle.

GAUGE
34 sts and 40 rnds = 4" (10 cm) in St st on larger needles.

FINISHED SIZE
18¾" (47.5 cm) circumference at brim, unstretched; to fit 19–22" (48.5–56 cm) head circumference.

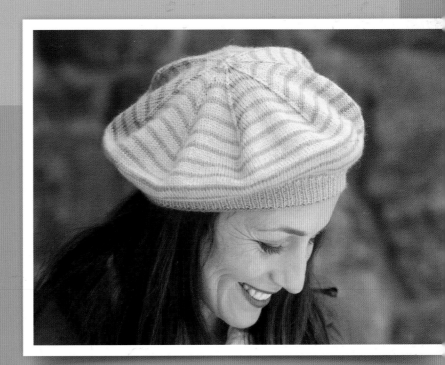

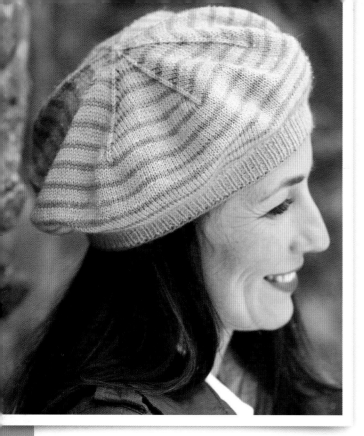

RIBBING

With smaller cir needle and CC, CO 160 sts. Place marker (pm) for beg of rnd and join to work in the rnd, being careful not to twist sts.

Rnd 1: With MC, knit.

Rnd 2: *K1, p1; rep from * to end.

Rep Rnd 2 until piece measures 1" (2.5 cm).

BODY

Change to larger needles.

Next rnd: (inc rnd) With MC, *k1, k1f&b; rep from * to end—240 sts. *Knit 2 rnds with CC. Knit 4 rnds with MC. Rep from * 6 more times. Knit 2 rnds with CC.

CROWN SHAPING

Note: Maintain stripe patt throughout decreases. Change to dpns when there are too few sts to work comfortably on cir needle.

Next rnd: (dec rnd) *K27, sl2-k1-p2sso, pm; rep from * 7 more times—224 sts rem.

Next rnd: Knit.

Next rnd: (dec rnd) *Knit to 3 sts before m, sl2-k1-p2sso; rep from * 7 more times—16 sts dec'd.

Rep last 2 rnds 12 more times—16 sts rem. Knit 1 rnd. Break yarn, leaving an 8" (20.5 cm) tail. With tail threaded on tapestry needle draw through rem sts, pull snug to tighten, and fasten off inside.

FINISHING

Weave in ends. Block over dinner plate to shape.

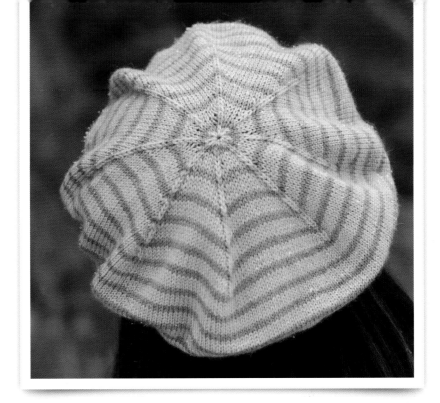

Tips and Techniques:
JOGLESS STRIPES

When knitting stripes in the round, one of the downfalls is the jump in color where one round transitions to the next. Knit one round in the new color. At the beginning of the next round, insert the right needle tip into the left leg of the stitch in the row below the first stitch of the round (old color stitch) and place this stitch on the left-hand needle **(figure 1)**. Knit this stitch together with the first stitch of the next round to raise the color of the previous round to the height of the new round **(figure 2)**. Do this at the beginning of every round that involves a color change.

FIGURE 1

FIGURE 2

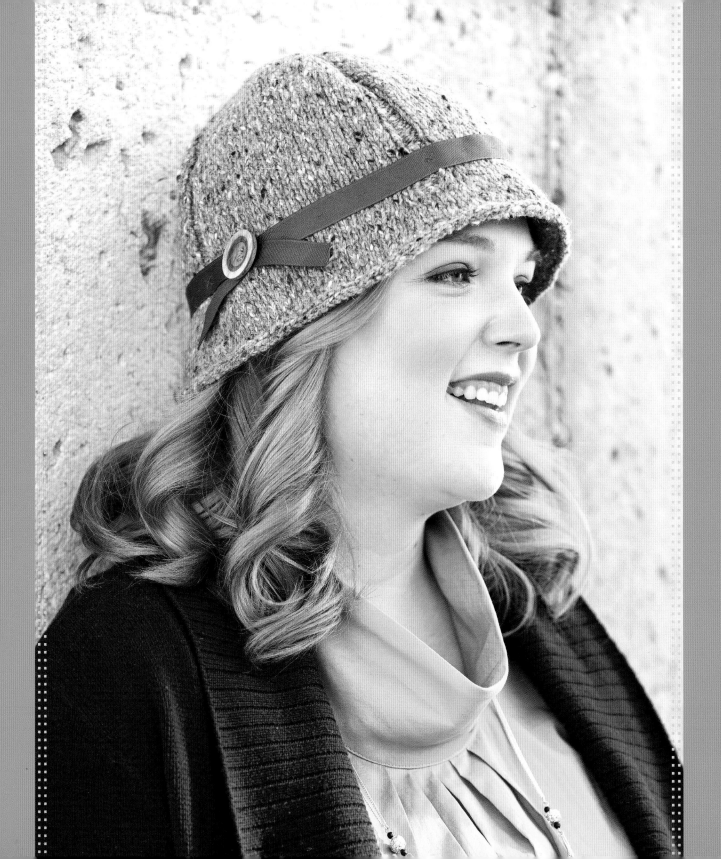

LEA CLOCHE
BY CECILY GLOWIK MACDONALD

This modern take on a classic cloche is stylish but also is a practical fall and winter accessory. Its curved brim protects against wind, rain, and snow, and its simple shape is the perfect canvas for embellishment. Showcase your artistic flair by adding a cute button and contrasting ribbon.

materials

YARN
Medium #4 (worsted weight).
Shown here: Berroco Blackstone Tweed (65% wool, 25% superkid mohair, 10% angora; 130 yd [119 m]/ 50 g): 2631 clover, 2 balls.

NEEDLES
U.S. size 6 (4 mm): 16" (40 cm) circular (cir) and set of 4 or 5 double-pointed (dpns). Adjust needle if necessary to obtain correct gauge.

NOTIONS
Markers (m); tapestry needle; 1⅛" (3 cm) button, 1 yd (1 m) ⅝" ribbon; sewing needle and thread to match ribbon; pins.

GAUGE
20 sts and 28 rows= 4" (10 cm) in St st.

FINISHED SIZE
21½" (54.5 cm) circumference on body of hat; to fit 20–22" (51–56 cm) head circumference.

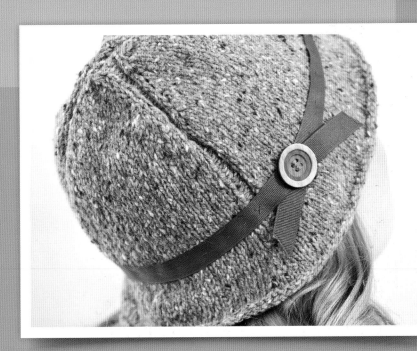

SHAPE CROWN

With dpns, CO 4 sts for crown of hat (see Glossary). Place marker (pm) for beg of rnd and join for working in the rnd, being careful not to twist sts.

Note: Change to cir needle when there are enough sts to work comfortably.

Rnd 1: (inc rnd) *P1f&b (see Glossary); rep from * to end—8 sts.

Rnd 2: Purl.

Rnd 3: (inc rnd) *P1f&b, p1; rep from * to end—12 sts.

Rnd 4: *P2, k1; rep from * to end.

Rnd 5: (inc rnd) *P2, knit into the [front, back, front] of next st (k1fbf); rep from * to end—20 sts.

Rnd 6: *P2, k3; rep from * to end.

Rnd 7: (inc rnd) *P2, k1, M1R, k1, M1L, k1; rep from * to end—28 sts.

Rnd 8: *P2, pm, k5, pm; rep from * to end (beg of rnd m counts as last m).

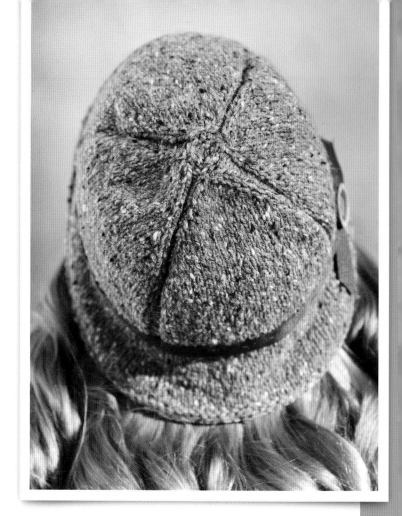

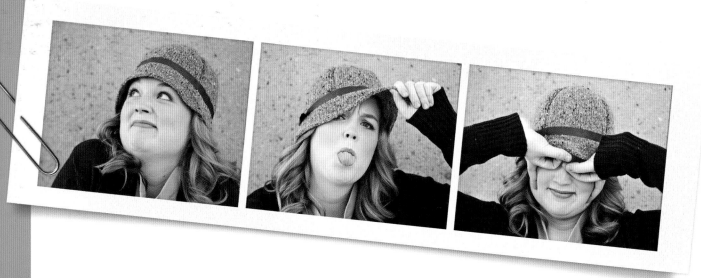

Rnd 9: (inc rnd) *P2, sl m, k1, M1R, knit to 1 st before m, M1L, k1; rep from * to end—8 sts increased.

Rnd 10: Work sts as they appear (knit the knits and purl the purls).

Rep last 2 rnds 9 more times—108 sts.

BODY
Work even in pattern as established until piece measures 6½" (16.5 cm).

BRIM
Next rnd: (inc rnd) *Knit to m, sl m, [M1R, k1] 2 times, knit to 2 sts before m, [M1L, k1] 2 times, sl m: rep from * to end—124 sts.

Knit 5 rnds.

Rep inc rnd 1 time—140 sts.

Purl 1 rnd.

BO all sts knitwise.

FINISHING
Block piece. Place hat on head and wrap ribbon around so that it fits slightly snugly around head and bottom of ribbon lines up with first brim inc rnd. Cross ribbon ends over each other and pin ends together. Cut ribbon, leaving a 3" (7.5 cm) tail on each end. Remove hat. Use center of one of the sections of St st as center front. Pin ribbon to hat where ends cross, about 8" (20.5 cm) from center front on right side of hat. Pin ribbon evenly around hat, and sew into place with sewing needle and thread. Sew button over cross in ribbon. Trim ribbon ends to desired length.

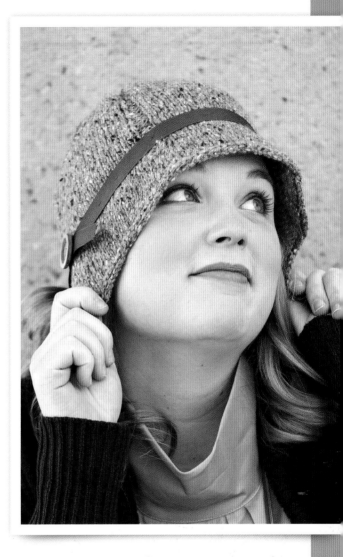

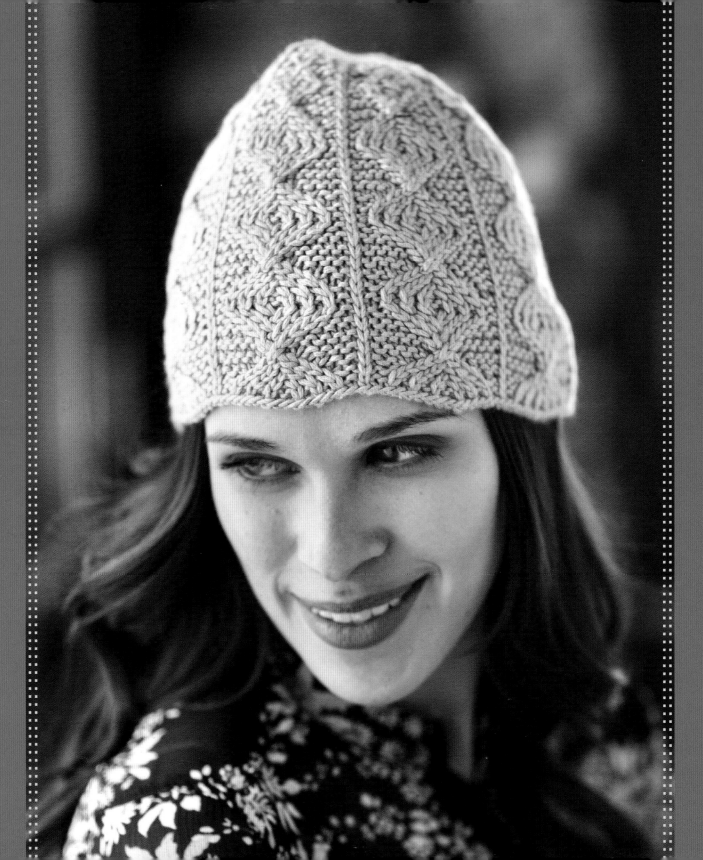

OGEE BEANIE

BY KIRSTEN KAPUR

Twisted stitches paired with a twisting cable pattern pop off the garter-stitch background in this gorgeous beanie. The cable pattern is neatly sectioned off and repeated around the hat.

materials

YARN

Medium #4 (worsted weight).
Shown here: Cascade Yarns Venezia Worsted (70% merino wool, 30% silk; 218 yd [200 m]/100 g): #173, 1 skein.

NEEDLES

U.S size 5 (3.75 mm): set of 5 double-pointed (dpn). *U.S. size 7 (4.5 mm):* set of 5 dpn. Adjust needle size if necessary to obtain correct gauge.

NOTIONS

Markers (m), cable needle (cn), tapestry needle.

GAUGE

25 sts and 37 rnds = 4" (10 cm) in Ogee patt.

FINISHED SIZE

19¼" (49 cm) circumference at brim; to fit 19–22" (48.5–56 cm) head circumference.

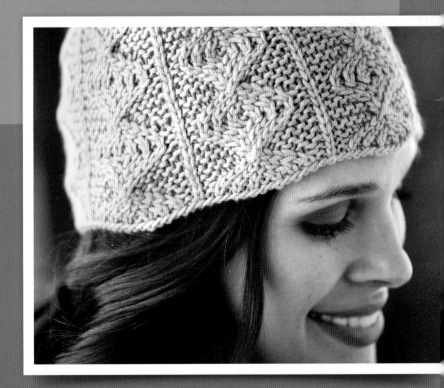

Stitch Guide

Left Twist (LT)

Sl 1 st to cn and hold in front, k1, k1 from cn.

Right Twist (RT)

Knit second st from tip of left needle but do not drop sts from left needle, knit st closest to tip of left needle, drop both sts from left needle.

Ogee Pattern

(multiple of 15 sts)

Rnd 1: *K1, LT 3 times, RT 3 times, k2; rep from * to end.

Rnd 2: *P2, LT 2 times, RT 3 times, p2, sl 1 purlwise (pwise) with yarn in back (wyb); rep from * to end.

Rnd 3: *K3, LT 2 times, RT 2 times, k4; rep from * to end.

Rnd 4: *P4, LT, RT 2 times, p4, sl 1 pwise wyb; rep from * to end.

Rnd 5: *K5, LT, RT, k6; rep from * to end.

Rnd 6: *P6, RT, p6, sl 1 pwise wyb; rep from * to end.

Rnd 7: *K5, RT, LT, k6; rep from * to end.

Rnd 8: *P4, RT 2 times, LT, p4, sl 1 pwise wyb; rep from * to end.

Rnd 9: *K3, RT 2 times, LT 2 times, k4; rep from * to end.

Rnd 10: *P2, RT 3 times, LT 2 times, p2, sl 1 pwise wyb; rep from * to end.

Rnd 11: *K1, RT 3 times, LT 3 times, k2; rep from * to end.

Rnd 12: *[P1, sl 1 pwise wyb] 3 times, p1, [p1, sl 1 pwise wyb] 4 times; rep from * to end.

Rnd 13: Knit.

Rnd 14: *[P1, sl 1 pwise wyb] 3 times, p1, [p1, sl 1 pwise wyb] 4 times; rep from * to end.

Crown Decreases

Rnd 1: *K1, LT 3 times, RT 3 times, k2; rep from * to end.

Rnd 2: *P2, LT 2 times, RT 3 times, p2, sl 1 pwise wyb; rep from * to end.

Rnd 3: *K2tog, k1, LT 2 times, RT 2 times, k1, ssk, k1; rep from * to end—104 sts rem.

Rnd 4: *P3, LT, RT 2 times, p3, sl 1 pwise wyb; rep from * to end.

Rnd 5: *K4, LT, RT, k5; rep from * to end.

Rnd 6: *P5, RT, p5, sl 1 pwise wyb; rep from * to end.

Rnd 7: *K2tog, k2, RT, LT, k2, ssk, k1; rep from * to end—88 sts rem.

Rnd 8: *P2, RT 2 times, LT, p2, sl 1 pwise wyb ; rep from * to end.

Rnd 9: *K1, RT 2 times, LT 2 times, k2; rep from * to end.

Rnd 10: *P1, LT 2 times, RT 2 times, p1, sl 1 pwise wyb; rep from * to end.

Rnd 11: *K2tog, LT, RT 2 times, ssk, k1; rep from * to end—72 sts rem.

Rnd 12: *P2, LT, RT, p2, sl 1 pwise wyb; rep from * to end.

Rnd 13: *K3, RT, k4; rep from * to end.

Rnd 14: *P2, RT, LT, p2, sl 1 pwise wyb; rep from * to end.

Rnd 15: *K2tog, LT, RT, ssk, k1; rep from * to end—56 sts rem.

Rnd 16: *P2, RT, p2, sl 1 pwise wyb; rep from * to end.

Rnd 17: Knit.

Rnd 18: *P6, sl 1 pwise wyb; rep from * to end.

Rnd 19: *K2tog, k2, ssk, k1; rep from * to end—40 sts rem.

Rnd 20: *P4, sl 1 pwise wyb; rep from * to end.

Rnd 21: Knit.

Rnd 22: *P4, sl 1 pwise wyb; rep from * to end.

Rnd 23: *K2tog, ssk, k1; rep from * to end—24 sts rem.

Rnd 24: *P2, sl 1 pwise wyb; rep from * to end.

Rnd 25: [K3tog] to end—8 sts rem.

Crown Decrease Chart

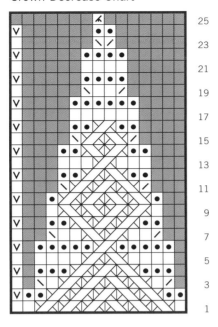

Legend:

	
□	knit
•	purl
⧄	sl 1 pwise wyb
⧅	k2tog
V	ssk
✓	no stitch
⟍	LT
⟋	RT
▨	k3tog
▢	pattern repeat

Ogee Chart

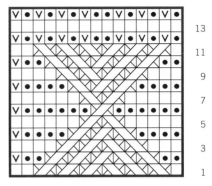

BODY

With smaller needles, CO 120 evenly over 4 dpns. Place marker (pm) for beg of rnd and join for working in the rnd, being careful not to twist sts.

Rnd 1: Knit.

Rnd 2: *[P1, sl 1 purlwise (pwise) with yarn in back (wyb)] 3 times, p1, [p1, sl 1 pwise wyb] 4 times; rep from * 7 more times.

Rnds 3 and 4: Rep Rnds 1 and 2.

Change to larger needles.

Work Rnds 1–14 of Ogee patt (see Stitch Guide or chart) 3 times.

Work Rnds 1–25 of Crown Decreases (see Stitch Guide or chart)—8 sts rem.

Break yarn, leaving an 8" (20.5 cm) tail. Thread tail onto tapestry needle and draw through rem sts, pull snug to tighten, and fasten off inside.

FINISHING

Weave in ends. Block, gently shaping scallops at brim.

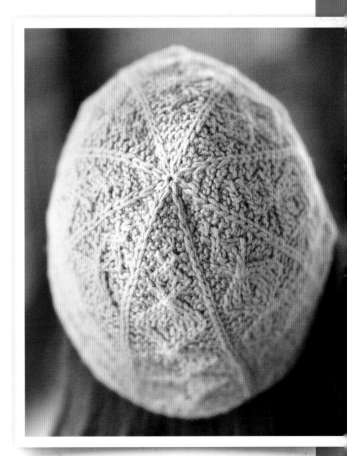

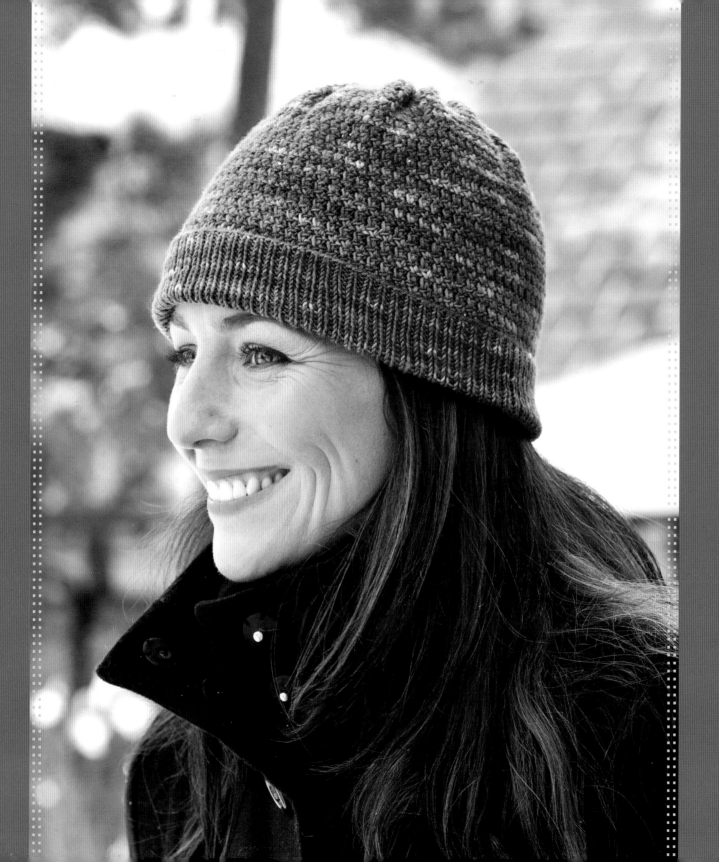

PEBBLED BEANIE

BY ELISABETH PARKER

This hat uses an allover textured stitch pattern to show off a beautiful hand-dyed sock yarn. Suitable for a man or a woman, the beanie sports a brim that folds over for a fitted look or unrolls to create a longer slouchy hat. The hat was cleverly designed to be knit from the inside out, which allows the fun stitch pattern to be worked without seams.

materials

YARN
Extra-fine #1 (fingering weight).
Shown here: Valley Yarns Semi-Solid Hand-Dyed Sock Yarn (100% merino; 382 yd [349 m]/100 g): velvet, 1 skein.

NEEDLES
U.S. size 2 (2.75mm): 16" (40 cm) circular (cir) and set of 4 double–pointed (dpn). Adjust needle size if necessary to obtain the correct gauge.

NOTIONS
Marker (m); tapestry needle.

GAUGE
34 sts and 40 rnds = 4" (10 cm) in pattern st.

FINISHED SIZE
19½" (49.5 cm) circumference at brim; 18¾" (47.5 cm) circumference in pattern st; to fit 19–22" (48.5–56 cm) head circumference.

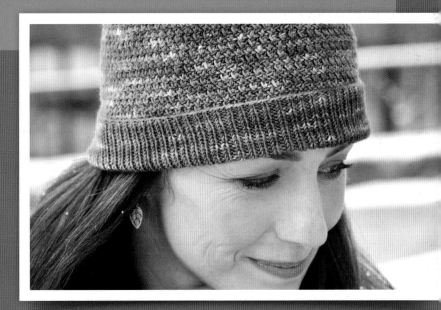

Stitch Guide

Pattern Stitch

(multiple of 2 sts)

Rnd 1: *P2tog, leaving sts just worked on left needle, k2tog in same sts, drop worked sts from left needle; rep from * to end.

Rnd 2: Remove m, sl 1 purlwise (pwise) with yarn in front (wyf), replace m for beg of rnd, purl to end.

Note: Hat is worked with WS facing at all times.

RIBBING

CO 152 sts. Place marker (pm) for beg of rnd. Join for working in the rnd, being careful not to twist sts.

Rnd 1: *K1, p1; rep from * to end.

Rep last rnd until piece measures 2" (5 cm) from CO edge.

BODY

Next rnd: (inc rnd) *P19, M1P, rep from * to end—160 sts.

Work in Pattern st until hat measures 9" (23 cm) from CO edge, ending with Rnd 1.

SHAPE CROWN

Note: Switch to dpns when there are too few sts to work comfortably on cir needle.

Rnd 1: (dec rnd) Remove m, sl 1 pwise wyf, replace m for beg of rnd, *p2tog; rep from * to end—80 sts rem.

Rnd 2: Work Rnd 1 of Pattern st.

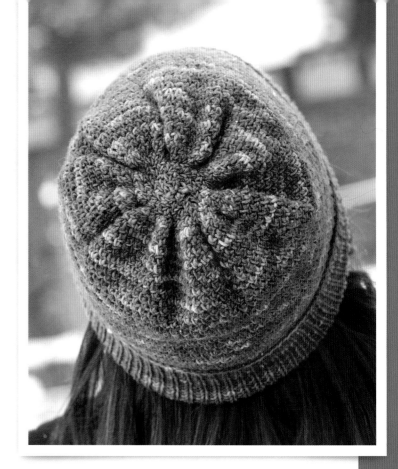

Rep Rnds 1 and 2 three more times, then rep Rnd 1 once more—5 sts rem.

Break yarn, leaving an 8" (20.5 cm) tail. With tail threaded on tapestry needle, draw through rem sts, pull snug to tighten, and fasten off outside.

Turn hat right side out.

FINISHING

Weave in ends on WS (inside) of hat. Fold up brim and block. If desired, tack down brim to fold permanently.

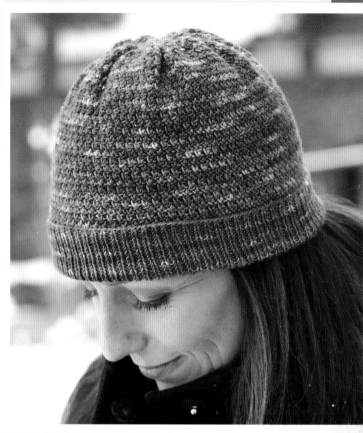

PEBBLED BEANIE

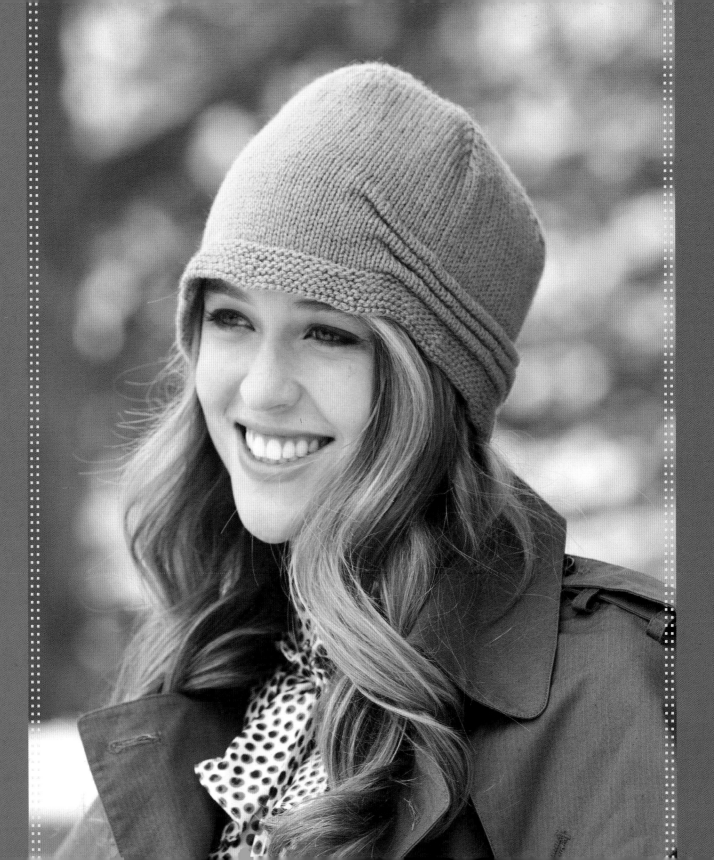

WELTED TOQUE

BY MELISSA LABARRE

T This hat is a new take on a classic stockinette cap. Decreases form a slightly rippled brim, while three welts of varying lengths create an asymmetrical shape. Long enough to cover the ears, it's a fun but practical winter accessory.

materials

YARN
Fine #2 (sportweight).
Shown here: St-Denis Nordique (100% wool; 150 yd [137 m]/50 g): #5897 olive, 2 balls.

NEEDLES
U.S. size 5 (3.75 mm): 16" (40 cm) circular (cir) and set of 4 double-pointed (dpn). Adjust needle size if necessary to obtain the correct gauge.

NOTIONS
Marker (m); tapestry needle.

GAUGE
23 sts and 32 rnds = 4" (10 cm) in St st.

FINISHED SIZE
20¾" (52.5 cm) circumference at body; to fit 21–24" (53.5–61 cm) head circumference.

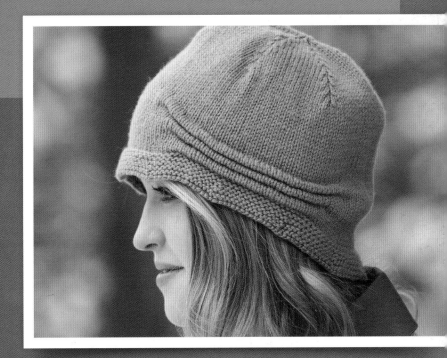

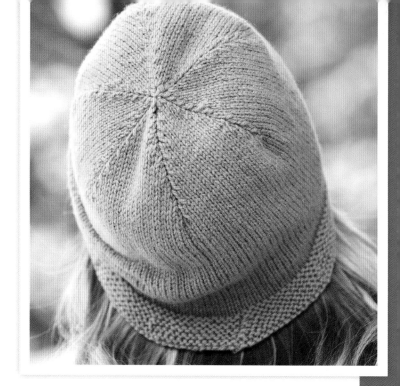

Stitch Guide

Welt

*With left needle, pick up the purl bump on WS of work 6 sts below the st on left needle; knit tog with next st on left needle; rep from * as directed.

BRIM

With cir needle, CO 150 sts. Place marker (pm) and join for working in the rnd, being careful not to twist sts.

Rnd 1: Knit.

Rnd 2: Purl.

Rnd 3: *K13, k2tog; rep from * to end—140 sts.

Rnd 4: Purl.

Rnd 5: *K12, k2tog; rep from * to end—130 sts.

Rnd 6: Purl.

Rnd 7: *K11, k2tog; rep from * to end—120 sts.

Rnd 8: Purl.

Rnd 9: Knit.

Rnd 10: Purl.

BODY

Knit 7 rnds.

Next rnd: K20, make welt (see Stitch Guide) over next 25 sts, knit to end.

Knit 7 rnds.

Next rnd: K17, make welt over next 31 sts, knit to end.

Knit 7 rnds.

Next rnd: K14, make welt over next 37 sts, knit to end.

Work in St st until piece measures 6" (15 cm) from CO (measuring on plain side of hat).

SHAPE CROWN

Note: Change to dpns when there are too few sts to work comfortably on cir needle.

Rnd 1: (dec rnd) *K2tog, k16, ssk; rep from * to end—108 sts rem.

Rnds 2 and 3: Knit.

Rnd 4: *K2tog, k14, ssk; rep from * to end—96 sts rem.

Rnds 5 and 6: Knit.

Rnd 7: *K2tog, k12, ssk; repeat from * to end—84 sts rem.

Rnds 8 and 9: Knit.

Rnd 10: *K2tog, k10, ssk; rep from * to end—72 sts rem.

Rnds 11 and 12: Knit.

Rnd 13: *K2tog, k8, ssk; rep from * to end—60 sts rem.

Rnds 14 and 15: Knit.

Rnd 16: *K2tog, k6, ssk; rep from * to end—48 sts rem.

Rnd 17: Knit.

Rnd 18: *K2tog, k4, ssk; rep from * to end—36 sts rem.

Rnd 19: Knit

Rnd 20: *K2tog, k2, ssk; rep from * to end—24 sts rem.

Rnd 21: Knit.

Rnd 22: *K2tog, ssk; rep from * to end—12 sts rem.

Rnd 23: *K2tog; rep from * to end—6 sts rem.

Break yarn, leaving an 8" (20.5 cm) tail. With tail threaded on tapestry needle, draw through rem sts, pull snug to tighten, and fasten off inside.

FINISHING
Weave in ends. Block.

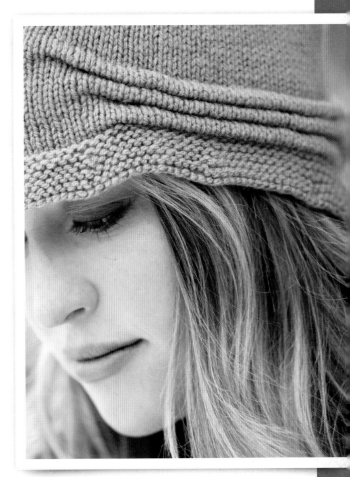

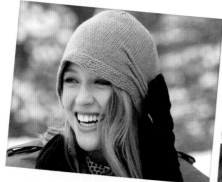
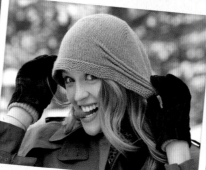
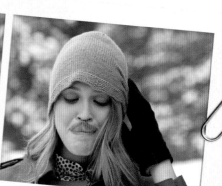

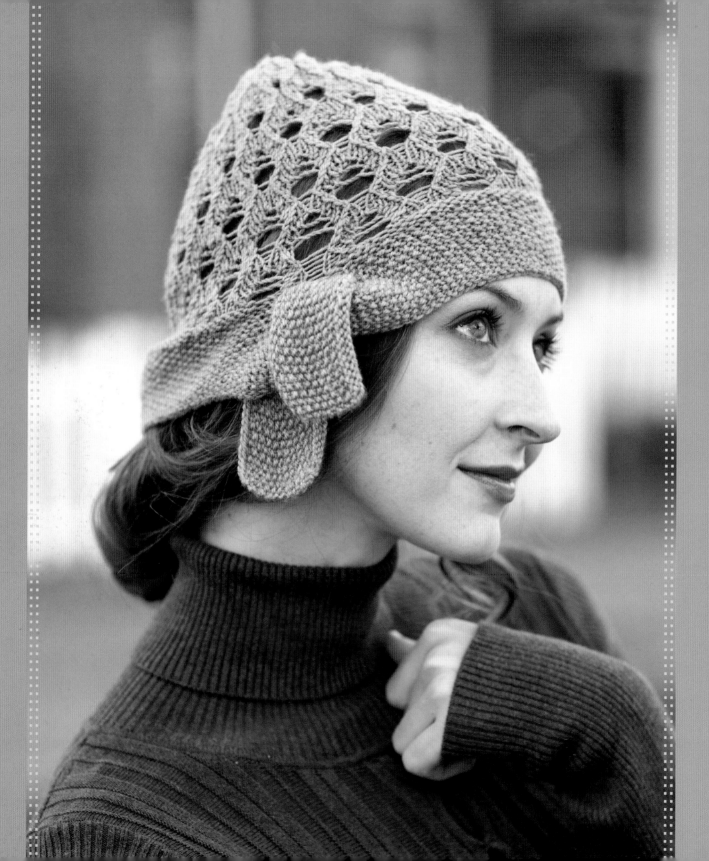

ANNEX SNOOD

BY CIRILIA ROSE

The open-lace pattern and lightweight yarn used in this snood combine to form a head covering that can be worn year-round. The lovely tie not only adds a pretty design element, but also ensures a perfect fit. This is the ideal project for utilizing that special skein of hand-dyed sock yarn in your stash. Knit the hat to a larger size if you have lots of hair to tuck into the snood.

materials

YARN
Extra fine #1 (fingering weight).
Shown here: Dream in Color Smooshy
(100% superwash merino, 450 yd
[411 m]/113 g): #240 wisterious, 1 skein.

NEEDLES
U.S. size 4 (3.5 mm): 16" (40 cm) circular
(cir) and set of 5 double-pointed (dpn).
Adjust needle size if necessary to obtain
the correct gauge.

NOTIONS
Marker (m), tapestry needle.

GAUGE
22 sts and 48 rows = 4" (10 cm) in seed
stitch.

FINISHED SIZE
17½" (44.5 cm) circumference on
body; to fit 18–22" (45.5–56 cm) head
circumference.

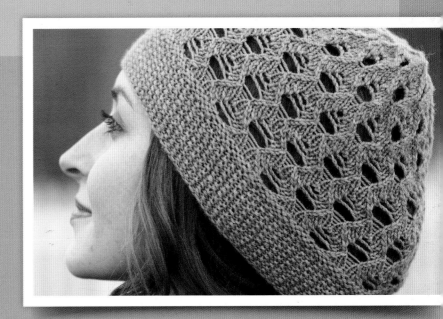

Stitch Guide

Seed Stitch

(multiple of 2 sts)

Row 1: (WS) *K1, p1; rep from * to end.

Row 2: (RS) *P1, k1; rep from * to end.

Bumblebee Lace

(multiple of 8 sts)

Rnd 1: *K2, k2tog, [yo] twice, ssk, k2; rep from * to end.

Rnds 2, 4, and 6: *K3, [p1, k1] into double yo, k3; rep from * to end.

Rnd 3: *K1, k2tog, k1, [yo] twice, k1, ssk, k1; rep from * to end.

Rnd 5: *K2tog, k2, [yo] twice, k2, ssk; rep from * to end.

Rnd 7: *[Yo] twice, ssk, k4, k2tog; rep from * to end.

Rnds 8 and 10: *[P1, k1] into double yo, k6; rep from * to end, remove m, sl 1 st pwise wyb, replace m.

Rnd 9: *[Yo] twice, k1, ssk, k2, k2tog, k1; rep from * to end.

Rnd 11: *[Yo] twice, k2, ssk, k2tog, k2; rep from * to end.

Rnd 12: Rep Rnd 8.

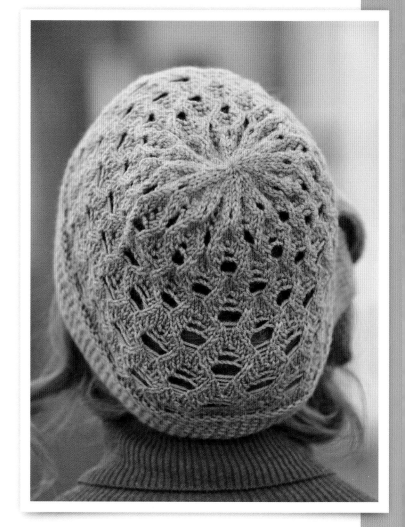

STRAP

With cir needle, CO 162 sts.

Purl 1 RS row.

Work in Seed st (see Stitch Guide) for 1¾" (4.5 cm), ending after a RS row.

Knit 1 WS row.

Next row: BO 33 sts purlwise (pwise), k96, p33—129 sts rem.

Next row: BO 33 sts knitwise (kwise), return last BO st to left needle—96 sts rem.

Turn so RS is facing. Place marker (pm) and join for working in the rnd.

Legend

- ☐ knit
- ☒ purl
- ☒ k2tog
- ☒ yo
- ☒ ssk
- ☒ sl 1 pwise wyb
- ▨ no stitch
- ☐ pattern repeat

Bumblebee Chart

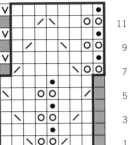

Decrease Chart

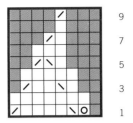

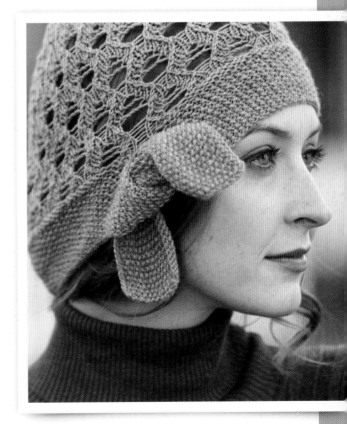

BODY

Knit 1 rnd.

Work in Bumblebee Lace patt until piece measures about 7½"
(19 cm) from CO edge, ending after Rnd 6 of patt.

SHAPE CROWN

Note: Change to dpns when there are too few sts to work
comfortably on cir needle.

Work 9 rnds of Decrease Chart—12 sts rem.

Break yarn, leaving an 8" (20.5 cm) tail. With tail threaded on
tapestry needle, draw through rem sts, pull snug to tighten, and
fasten off inside.

FINISHING

Weave in ends. Block. Tie strap ends.

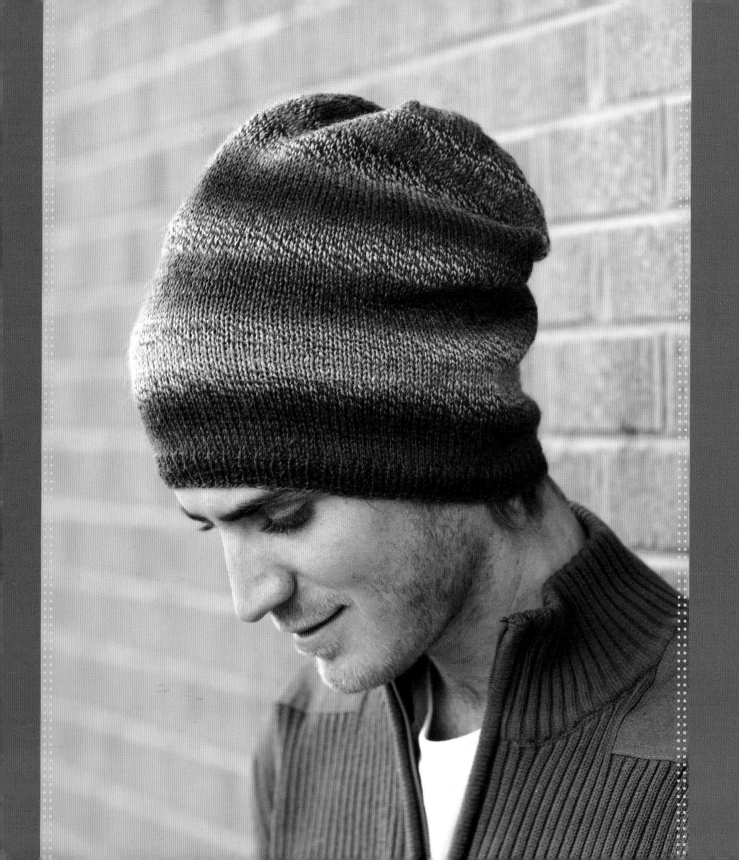

BRIER TOQUE

BY CECILY GLOWIK MACDONALD

A simple stockinette-stitch hat with an easy-fit ribbed brim is always a welcome gift. The use of a self-striping yarn and the slouchy shaping update this classic shape, which is suitable for a man or a woman.

materials

YARN
Extra-fine #1 (fingering weight).
Shown here: Schoppel Wolle Zauberball Crazy (75% merino, 25% nylon; 459 yd [420 m]/100 g): #1660, 1 ball.

NEEDLES
Ribbing—U.S. size 3 (3.25 mm): 16" (40 cm) circular (cir). *Body—U.S. size 5 (3.75 mm):* 16" (40 cm) cir and set of 4 or 5 double-pointed (dpns). Adjust needle size if necessary to obtain correct gauge.

NOTIONS
Markers (m); tapestry needle.

GAUGE
27 sts and 36 rnds = 4" (10 cm) in St st on larger needle.

FINISHED SIZE
17¾ (19½)" (45 [49.5] cm) circumference in St st; to fit 18–21" (20–23") (45.5–53.5 [51–58.5] cm) head circumference. Hat shown measures 19½" (49.5 cm).

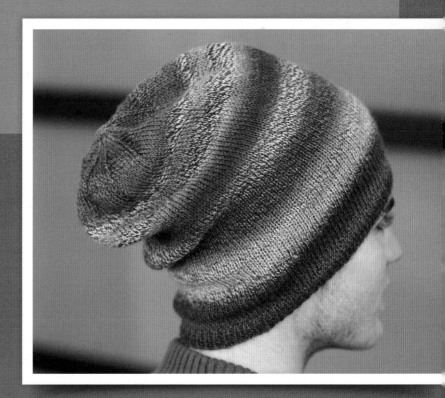

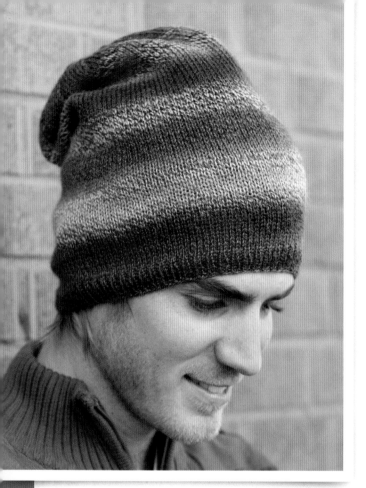

RIBBING

With smaller cir needle, CO 120 (132) sts. Place marker (pm) for begin of rnd and join for working in the rnd, being careful not to twist sts.

Rnd 1: *K1, p1; rep from * to end.

Rep last rnd until piece measures ¾" (2 cm) from CO edge.

BODY

Change to larger cir needle and work in St st until piece measures 10" (25.5 cm) from CO edge.

Next rnd: *K12, pm; rep from * to end (beg of rnd m counts as last m).

SHAPE CROWN

Note: Change to dpns when there are too few sts to work comfortably on cir needle.

Next rnd: (dec rnd) *Knit to 2 sts before m, k2tog, sl m; rep from * to end—10 (11) sts decreased.

Next rnd: Knit.

Rep last 2 rnds 9 more times—20 (22) sts rem.

Next rnd: (dec rnd) *K2tog; rep from * to end, removing all m except m for end of rnd—10 (11) sts rem.

Knit 1 rnd.

Next rnd: (dec rnd) [K2tog] 5 times, k 0 (1)—5 (6) sts rem.

Break yarn, leaving a 6" (15 cm) tail. With tail threaded on tapestry needle, draw through rem sts, pull snug to tighten, and fasten off inside.

FINISHING
Weave in ends. Block lightly, leaving rib band relaxed.

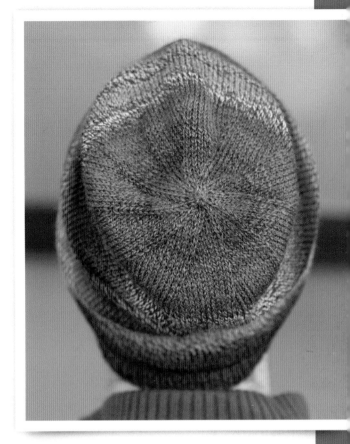

Tips and Techniques: CLOSING THE TOP OF A HAT WORKED FROM THE BRIM UP

A traditional way to work a hat is from the brim up, with stitches decreased at the top. Often this means that you decrease down to a small number of stitches and then cut the yarn, leaving a tail to thread through the remaining live stitches. To close neatly, make sure that when cutting the yarn, you have at least a 6" (15 cm) tail left. Thread the tail through a blunt needle and then thread the blunt needle and tail through the stitches that remain on the needles. I have found that if you thread the tail through the live stitches twice and then pull tight to close, you have a neat finish to the hat.

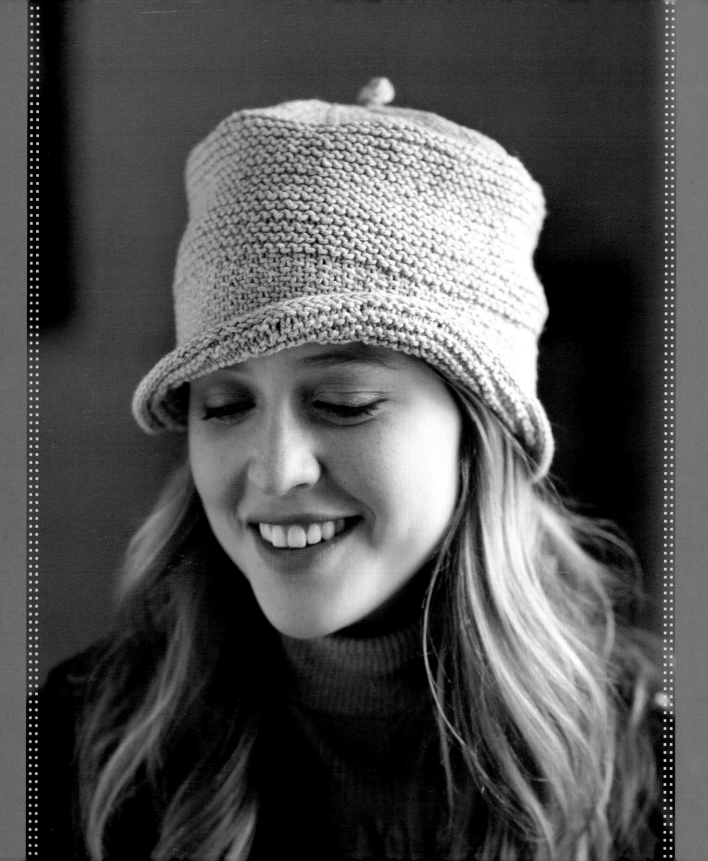

SHORE HAT

BY KRISTEN TENDYKE

A combination of simple stitch patterns forms this distinctively shaped hat that calls to mind walks along the seashore. A length of wire added to the edge of the brim provides a flexible but stable trim that is a unique design detail.

materials

YARN

Medium #4 (worsted weight). *Shown here:* O-Wool Balance (50% certified organic merino, 50% certified organic cotton; 130 yd [120 m]/50 g): #2026 opal, 2 balls.

NEEDLES

*Crown—*U.S. size 6 (4 mm): set of 5 double-pointed (dpn). *I-Cord (dpn), Body, Band and Brim (cir)—*U.S. size 5 (3.75 mm): 16" (40 cm) cir and set of 2 double-pointed (dpn). *Brim—*U.S. size 4 (3.5 mm): 16" (40 cm) circular (cir). *I-Cord BO—*U.S. size 3 (3.25 mm): set of 2 double-pointed (dpn). Adjust needle sizes if necessary to obtain the correct gauge.

NOTIONS

Marker (m); tapestry needle; machine-washable waste yarn (optional); wire cutters; firm jewelry wire.

GAUGE

20 sts and 36 rnds = 4" (10 cm) in garter st with medium needles; 19 sts and 48 rnds = 4" (10 cm) in slipped st patt (as worked for band) with medium needles.

FINISHED SIZE

20½" (52 cm) circumference at band; to fit 20–23" (51–58.5 cm) head circumference.

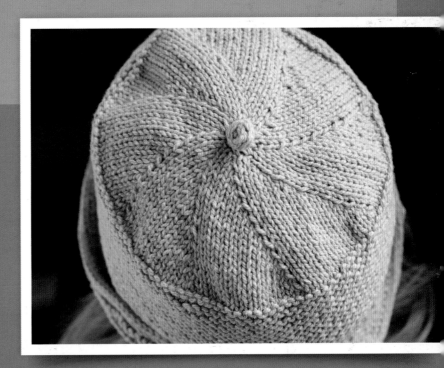

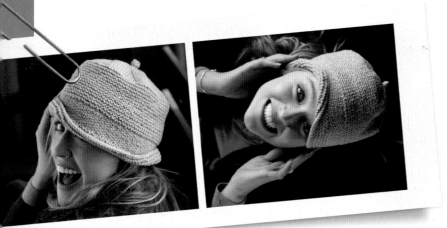

TOP I-CORD

With middle size set of 2 dpns, CO 4 sts. Work I-cord (see Glossary) for 1½" (4 cm).

Change to largest size set of 4 dpns.

SHAPE CROWN

Rnd 1: (inc rnd) *K1, yo; rep from * to end—8 sts. Distribute sts evenly over 4 dpns.

Join for working in the rnd, being careful not to twist sts.

Rnd 2: *K1, k1 through back loop (tbl); rep from * to end.

Rnd 3: (inc rnd) *K1f&b; rep from * to end—16 sts.

Rnd 4: Knit.

Rnd 5: (set-up rnd) *K1, place marker (pm), RLI (see Glossary); rep from * to end—24 sts.

Rnd 6: Knit.

Rnd 7: (inc rnd) Knit to 1 st before m, RLI, sl m; rep from * to end—8 sts increased.

Rnd 8: Knit.

Rep Rnds 7 and 8 nine more times—104 sts.

BODY

Change to larger cir needle.

Rnd 1: Purl.

Rnd 2: Knit.

Rep Rnds 1 and 2 fourteen more times, decreasing 1 st at end of last rnd—103 sts. Piece measures about 3½" (9 cm) from last inc rnd.

BAND

Rnd 1: Sl 1 purlwise (pwise) with yarn in front (wyf), *k1, sl 1 pwise wyf; rep from * to end.

Rnd 2: K1, *sl 1 pwise wyf, k1; rep from * to end.

Rep Rnds 1 and 2 six more times, then work Rnd 1 once more; band measures about 1¼" (3 cm).

BRIM

Rnd 1: Purl.

Change to smaller cir needle.

Rnd 2: (inc rnd) K1, *yo, k6; rep from * to end—120 sts.

Rnd 3: Purl, working yo from prev rnd tbl.

Rnd 4: Knit.

Rnd 5: Purl.

Change to larger cir needle.

Rnds 6 and 7: Rep Rnds 4 and 5.

Rnd 8: (inc rnd): K1, *yo, k7; rep from * to end—137 sts.

Rnd 9: Rep Rnd 3.

FINISHING

Slip sts onto waste yarn and block hat to measurements. Return held sts to larger cir and BO using the attached I-cord with wire (see Tips, opposite).

Tips and Techniques: ATTACHED I-CORD AND WIRE

Use cable method (see Glossary) to CO 2 sts **(figure 1)**. Work I-cord BO with U.S. size 3 dpn as foll: k2, k2tog tbl. Slide one end of wire between second and third st on the right needle **(figure 2)**; pull a few inches of wire through to prevent it from sliding back through. *Slip 3 sts from right needle back to left needle **(figure 3)**. Bring yarn under the wire to the back, then wrap over the wire and k2 **(figure 4)**, k2tog-tbl **(figure 5)** (keep wire to the back while knitting; **figure 6**); rep from * until only 3 sts rem on needle. Slip 3 sts from right needle back to left needle and BO rem sts. Break yarn leaving an 8" (20.5 cm) tail. Adjust the length of the wire to desired firmness around edge of hat. Cut wire with wire cutters, then twist the ends around each other to secure. Wiggle the twisted portion of the wire into the attached I-cord so CO and BO edges are flush. Thread tail of yarn onto tapestry needle and sew CO to BO edge, securing the wire underneath.

Weave in ends.

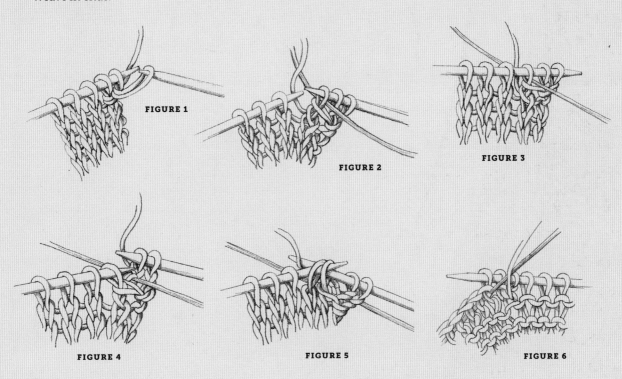

FIGURE 1

FIGURE 2

FIGURE 3

FIGURE 4

FIGURE 5

FIGURE 6

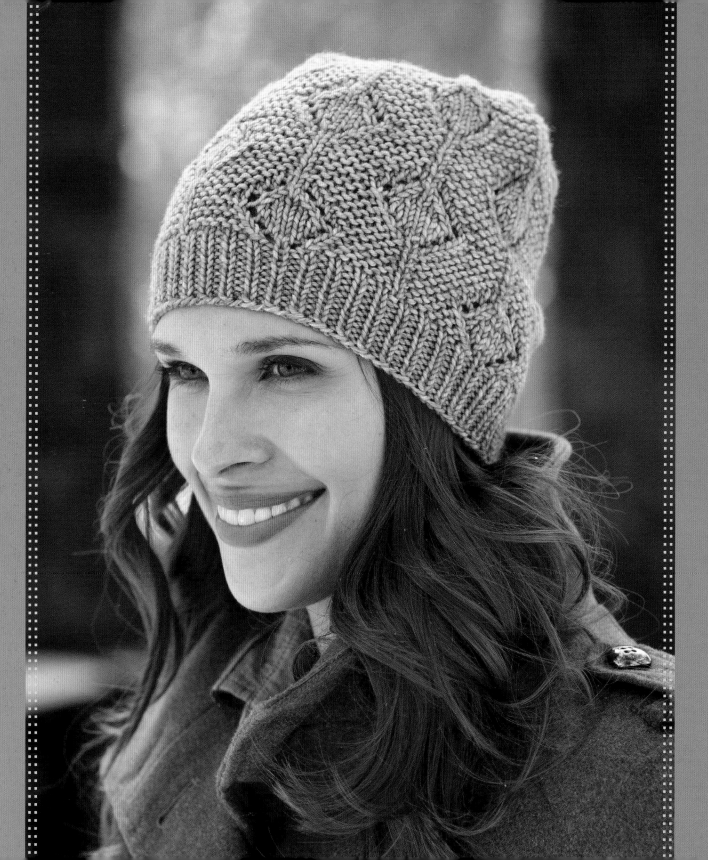

LEAVES LONG BEANIE

BY MELISSA LABARRE

Simple little leaves travel across a garter-stitch background and flow neatly into the decreases in this elongated beanie. Wear it slouched back on the head in the fall or pull it down over your ears when the weather gets colder. The garter-stitch background highlights the color variation in this semisolid yarn.

materials

YARN
Medium #4 (worsted weight).
Shown here: Madelinetosh Vintage (100% superwash merino; 200 yd [183 m]/100 g): nectar, 1 skein.

NEEDLES
Ribbing—U.S. size 5 (3.75 mm): 16" (40 cm) circular (cir) needle. *Body—U.S. size 7 (4.5 mm):* 16" (40 cm) cir needle and set of 4 double-pointed (dpn). Adjust needle sizes if necessary to obtain the correct gauge.

NOTIONS
Stitch marker (m); tapestry needle.

GAUGE
20 sts and 36 rnd = 4" (10 cm) in garter st; 21 sts and 32 rnds = 4" (10 cm) in k1, p1 ribbing, unstretched, with smaller needle.

FINISHED SIZE
17¼" (44 cm) circumference at brim; to fit 18–22½" (45.5–57 cm) head circumference.

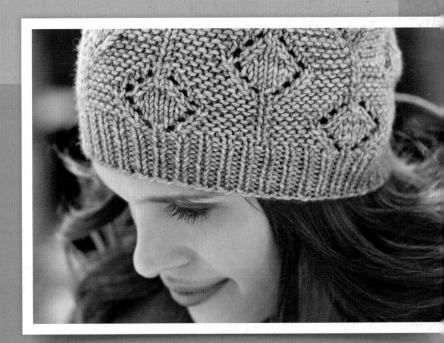

RIBBING

With smaller cir needle, CO 90 sts. Place marker (pm) for beg of rnd and join for working in the rnd, being careful not to twist sts.

Rnd 1: *K1, p1; rep from * to end.

Rep the previous rnd 9 more times.

BODY

Switch to larger cir needle. Work Garter Leaf Chart 2 times (48 rnds).

SHAPE CROWN

Note: Change to dpns when there are too few sts to work comfortably on cir needle.

Work 15 rnds of Decrease Chart—10 sts rem.

Next rnd: (dec rnd) *K2tog; rep from * to end—5 sts rem.

Break yarn, leaving an 8" (20.5 cm) tail. With tail threaded on tapestry needle, draw through rem sts, pull snug to tighten, and fasten off inside.

FINISHING

Weave in ends. Block hat using preferred method.

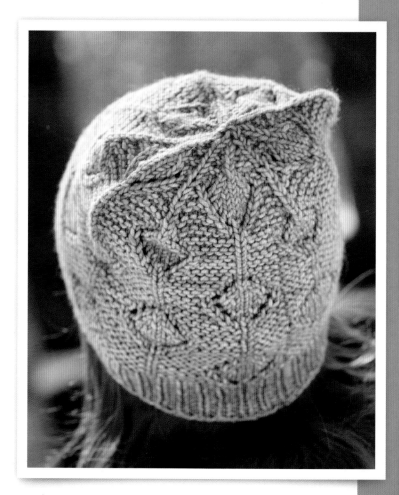

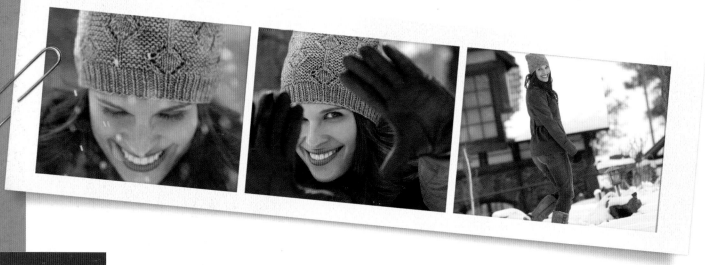

Garter Leaf Chart

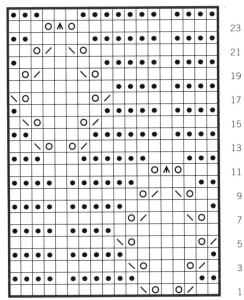

Decrease Chart

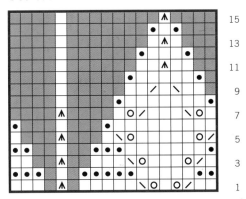

	knit
	purl
	k2tog
	ssk
	yo
	sl 2, k1, p2sso
	no stitch
	pattern repeat

Tips and Techniques: USING STITCH MARKERS TO KEEP TRACK OF PATTERN REPEATS

When a stitch pattern is repeated several times around the circumference of a hat, it can sometimes be difficult to keep track of where you are in the pattern. If you find that you tend to lose your place, try placing contrasting stitch markers after each pattern repeat. This way, you can catch errors within each repeat, rather than reaching the end of a row and finding that you have too many or too few stitches to complete the pattern.

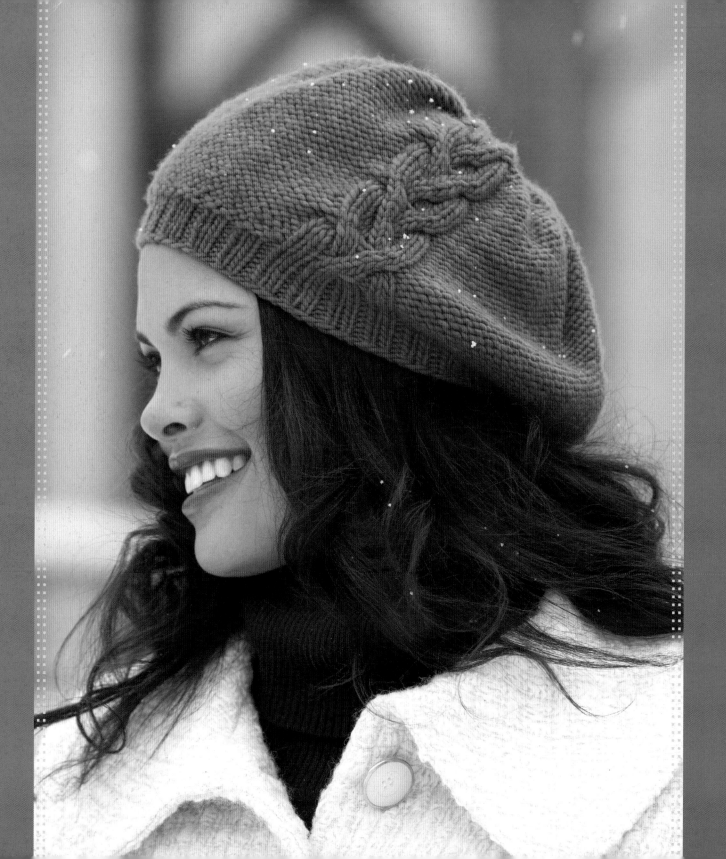

SOLITAIRE BERET

BY NATALIE LARSON

This classic beret shape is updated with a reverse stockinette background. A single cable running up just one side gives it a modern feel. When knit in a single-ply merino, the finished fabric and stitches have a soft, relaxed look.

materials

YARN
Medium #4 (worsted weight).
Shown here: Malabrigo Merino
Worsted (100% merino wool; 210 yd
[192 m]/100 g): #123 Rhodesian, 1 skein.

NEEDLES
Ribbing—U.S. size 8 (5 mm): 16" (40 cm)
circular (cir) needle. *Body—U.S. size 9
(5.5 mm):* 24" (60 cm) cir and set of 4
double-pointed (dpn). Adjust needle sizes
if necessary to obtain the correct gauge.

NOTIONS
Markers (m); cable needle (cn); tapestry
needle.

GAUGE
18 sts and 24 rnds = 4" (10 cm) in reverse
St st with larger needle.

FINISHED SIZE
18" (42.5 cm) circumference at brim;
to fit 19–22" (48.5–56 cm) head
circumference.

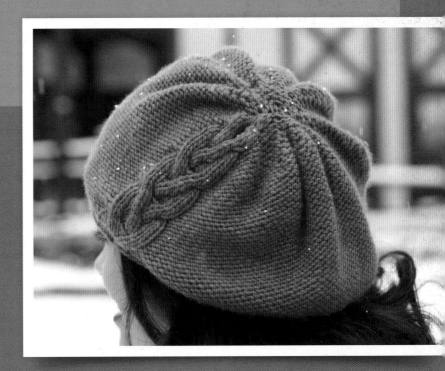

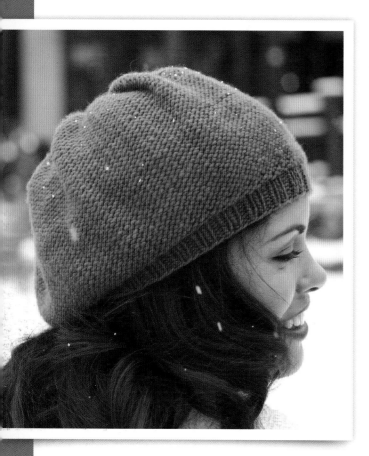

Rnds 3–35: Purl to m, sl m, work 12 sts in Cable Panel to m, sl m, purl to end; ending after rnd 15 of patt.

SHAPE CROWN

Rnd 1: (dec rnd) Purl to m, work Rnd 16 of Cable Panel to m, *p17, p2tog; rep from * to end—111 sts rem.

Rnd 2: Purl to m, work Rnd 17 of Cable Panel to m, purl to end.

Rnd 3: (dec rnd) [P7, p2tog] 3 times, work Rnd 18 of Cable Panel to m, *p7, p2tog; rep from * to end—100 sts rem.

Rnd 4: Purl to m, work Rnd 19 of Cable Panel to m, purl to end.

Rnd 5: (dec rnd) [P6, p2tog] 3 times, work Rnd 20 of Cable patt, *p6, p2tog; rep from * to end—89 sts rem.

Rnd 6: (dec rnd) [P5, p2tog] 3 times, [k1, ssk] 4 times, *p5, p2tog; rep from * to end—74 sts rem.

Rnd 7: (dec rnd) [P4, p2tog] 3 times, k8, *p4, p2tog; rep from * to end—63 sts rem.

Rnd 8: (dec rnd) [P3, p2tog] 3 times, [ssk] 4 times, *p3, p2tog; rep from * to end—48 sts rem.

Rnd 9: (dec rnd) [P2, p2tog] 3 times, sl 2 sts to cn and hold in front, k2 from left needle, k2 from cn, *p2, p2tog; rep from * to end—37 sts rem.

Rnd 10: (dec rnd) [P1, p2tog] 3 times, [ssk] 2 times, *p1, p2tog; rep from * to end—24 sts rem.

Rnd 11: (dec rnd) [P2tog] 3 times, ssk, *p2tog; rep from * to end—12 sts rem.

Rnd 12: (dec rnd) *P2tog; rep from * to end—6 sts rem.

Break yarn, leaving an 8" (20.5 cm) tail. With tail threaded on tapestry needle, draw through rem sts, pull snug to tighten, and fasten off inside.

FINISHING

Weave in ends. Block over a plate or pie tin to shape.

RIBBING

With smaller needles, CO 81 sts. Place marker (pm) and join for working in the rnd, being careful not to twist sts.

Rnd 1: *K2, p1; rep from * to end.

Rep last rnd 7 more times.

BODY

Rnd 1: P18, pm, work 12 sts in Cable Panel, pm, p51.

Change to larger cir needle.

Rnd 2: (inc rnd) [P1, p1f&b (see Glossary)] 9 times, sl m, work Rnd 2 of Cable patt, sl m, p1, *p1f&b, p1; rep from * to end—115 sts.

Cable Panel Chart

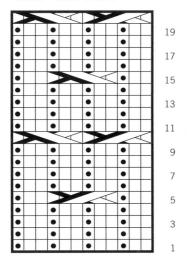

19
17
15
13
11
9
7
5
3
1

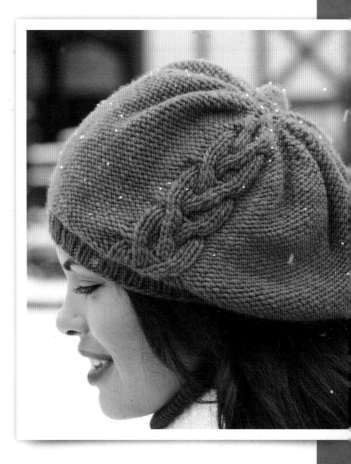

	knit
●	purl

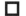 sl 3 sts to cn and hold in front; k2, p1 from left needle; k2, p1 from cn

 sl 3 sts to cn and hold in back; k2, p1 from left needle; k2, p1 from cn

☐ pattern repeat

Tips and Techniques: A FEW NOTES ON FIT

Often a hat will have a finished size that is smaller than the average adult head. That's because hats meant to fit closely at the brim need a bit of negative ease to help them fit snugly and keep them on the head. The amount of negative ease refers to the difference between the finished size of the object and the size of body part on which it will be worn. A hat that measures 19" (48.5 cm) around and is worn on a 22" (56 cm) head has 3" (7.5 cm) of negative ease.

A beret-type hat might have negative ease at the brim, but a few inches of positive ease in the body of the hat. The extra fabric is what creates its loose, flowing shape, while the tighter brim keeps it fitted to the head.

SOLITAIRE BERET

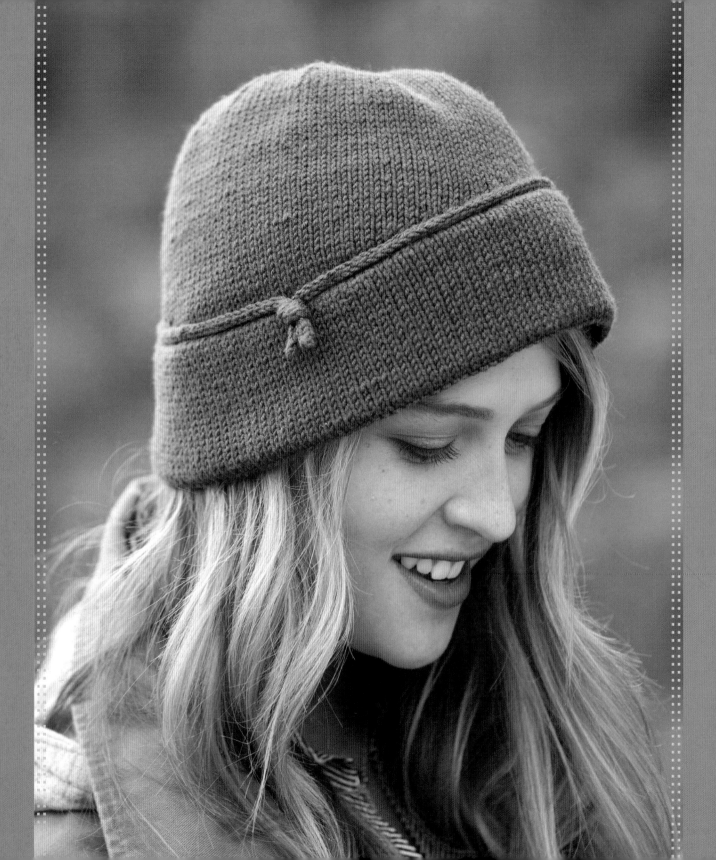

LAYERED CLOCHE

BY LAURA IRWIN

Short-rows give an unusual shape to this stunning cloche. Its chic form, which conveniently covers one's ears, is deceptively warm. This hat is a perfectly practical, yet dressy, accessory that works well even in deep winter.

materials

YARN
Light #3 (DK weight).
Shown here: Sublime Cashmere Merino Silk DK (75% extrafine merino wool, 20% silk, 5% cashmere; 127 yd [116 m]/50 g): #105 treacle, 3 skeins.

NEEDLES
U.S. size 5 (3.75 mm): Two 16" (40 cm) circular (cir) and set of 4 double-pointed (dpn). Adjust needle size if necessary to obtain the correct gauge.

NOTIONS
Markers (m), sewing needle and matching thread; sewing pins; head-shaped blocking form (optional), tapestry needle.

GAUGE
24 sts and 32 rows/rnds = 4" (10 cm) in St st.

FINISHED SIZE
20" (51 cm) circumference at join of brims; to fit 21½–22½" (54.5–57 cm) head circumference.

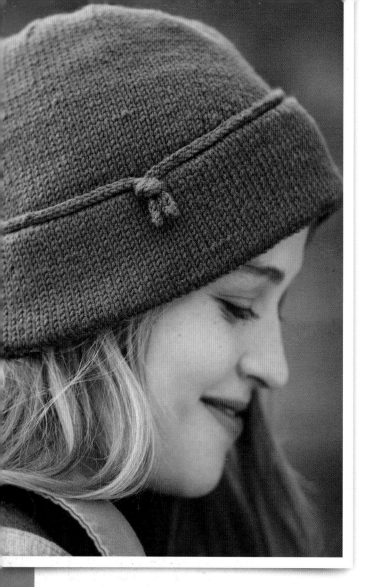

Hem

Fold piece at turning rnd so that CO edge is behind sts on needle. WS's of each half are facing each other and RS's are facing out.

Next rnd: (joining rnd) *Insert right needle in next st on left needle, insert right needle in corresponding st from CO row, knit 1 live st tog with 1 st from CO; rep from * to end.

Next rnd: (dec rnd) *K6, k2tog; rep from * to last 2 sts, k2tog—120 sts rem. Break yarn and set aside.

INNER BRIM

With second cir needle, CO 69 sts. Do not join; work back and forth in rows.

Beg with a WS row, work 6 rows in St st.

Next row: (WS; turning row) Knit.

Beg with a RS row, work 6 rows in St st.

With CO tail threaded on a tapestry needle, weave in end.

Hem

Fold piece at turning row so that CO edge is behind sts on needle. WS's of each half are facing each other and RS's are facing out.

Next row: (RS; joining row) Join CO to live sts as for hem of outer brim; pick up and knit 4 sts along edge of hem through both layers—73 sts.

Next row: P73, pick up and purl (see Glossary) 4 sts along edge of hem through both layers—77 sts.

Next row: (RS; dec row) *K9, k2tog; rep from * 6 more times—70 sts.

Next row: Purl.

Short-Row Shaping

Work short-rows (see Glossary) as foll:

Next row: K50, wrap and turn (w&t).

OUTER BRIM

With one cir needle, CO 138 sts. Place marker (pm) to indicate beg of rnd and join for working in the rnd, being careful not to twist sts.

Knit 20 rnds. Purl 1 rnd (turning rnd). Knit 20 rnds.

With CO tail threaded on a tapestry needle, weave in end.

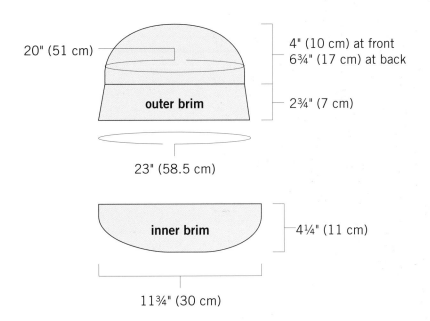

20" (51 cm)

4" (10 cm) at front
6¾" (17 cm) at back

outer brim

2¾" (7 cm)

23" (58.5 cm)

inner brim

4¼" (11 cm)

11¾" (30 cm)

Next row: P30, w&t.

Next row: Knit to wrapped st, knit wrapped st hiding the wrap, k1, w&t.

Next row: Purl to wrapped st, purl wrapped st hiding the wrap, p1, w&t.

Rep the last 2 rows 8 more times, ending after a WS row— 66 sts worked.

Next row: Knit to wrapped st, knit wrapped st hiding the wrap, knit to end.

Next row: Purl to wrapped st, purl wrapped st hiding the wrap, purl to end.

JOIN BRIMS

With RS of both brims facing, hold inner brim inside outer brim. Remove beg of rnd marker from outer brim; it will be replaced in a different location after short-rows are worked.

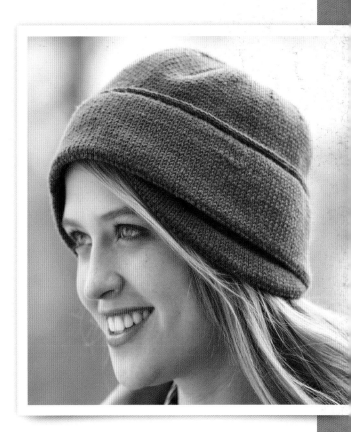

Next row: *Knit next st of outer brim tog with next st of inner brim; rep from * until all inner brim sts are joined, k39 from outer brim, w&t.

Next row: P28, w&t.

Next row: Knit to wrapped st, knit wrapped st hiding the wrap, k1, w&t.

Next row: Purl to wrapped st, purl wrapped st hiding the wrap, p1, w&t.

Rep the last 2 rows 8 more times, ending after a WS row—64 sts worked.

Next row: (RS) Knit to wrapped st, knit wrapped st hiding the wrap, k1, pm for new beg of rnd.

Knit 14 rnds.

SHAPE CROWN

Note: Switch to dpns when there are too few sts to work comfortably on cir needle.

Next rnd: (dec rnd) *K8, k2tog, pm; rep from * to end—108 sts rem.

Next rnd: Knit.

Next rnd: (dec rnd) *Knit to 2 sts before m, k2tog; rep from * to end—12 sts dec'd.

Rep last 2 rows 7 more times—12 sts rem.

Knit 1 rnd.

Next rnd: *K2tog; rep from * to end—6 sts rem.

Break yarn, leaving an 8" (20.5 cm) tail. Thread tail onto tapestry needle and draw through rem sts, pull snug to tighten, and fasten off inside. Block (see Blocking Tip).

I-CORD

CO 3 sts.

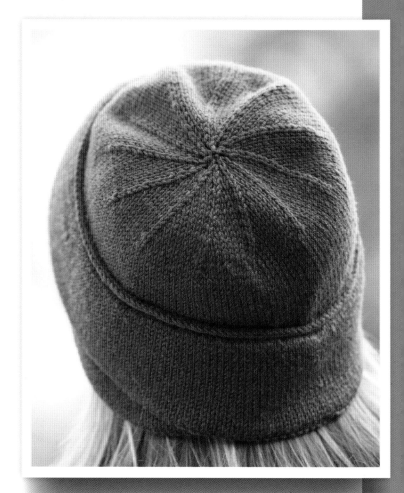

Work 3-st I-cord (see Tips and Techniques, opposite) for 24" (61 cm).

Next row: Sl 1, k2tog, psso—1 st rem. Break yarn, leaving a 4" (10 cm) tail, and draw through rem st. Weave in ends. Block.

FINISHING

Holding ends of I-cord tog, tie an overhand knot about 1" (2.5 cm) from ends. Adjust if necessary to fit over hat where outer and inner brims are joined (see photo). Position knot as shown above outer brim, and pin in place around hat. With sewing needle and thread, use running st (see Tips and Techniques, opposite) to sew I-cord to hat invisibly.

Tips and Techniques:

I-CORD (ALSO CALLED KNIT-CORD)

Using two double-pointed needles, cast on the desired number of stitches (usually 3 to 4). *Without turning the needle, slide stitches to other end of needle, pull the yarn around the back, and knit the stitches as usual. Repeat from * for desired length.

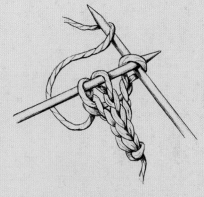

RUNNING STITCH

The most common sewing method. Holding the pieces to be joined together, pass a threaded needle from WS to RS and back, creating stitches that look like a small dashed line of equal lengths on both sides.

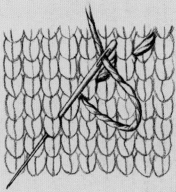

BLOCKING

A head form is very useful to shape the hat for blocking and to position the I-cord. Styrofoam head forms are available online or at some beauty supply stores.

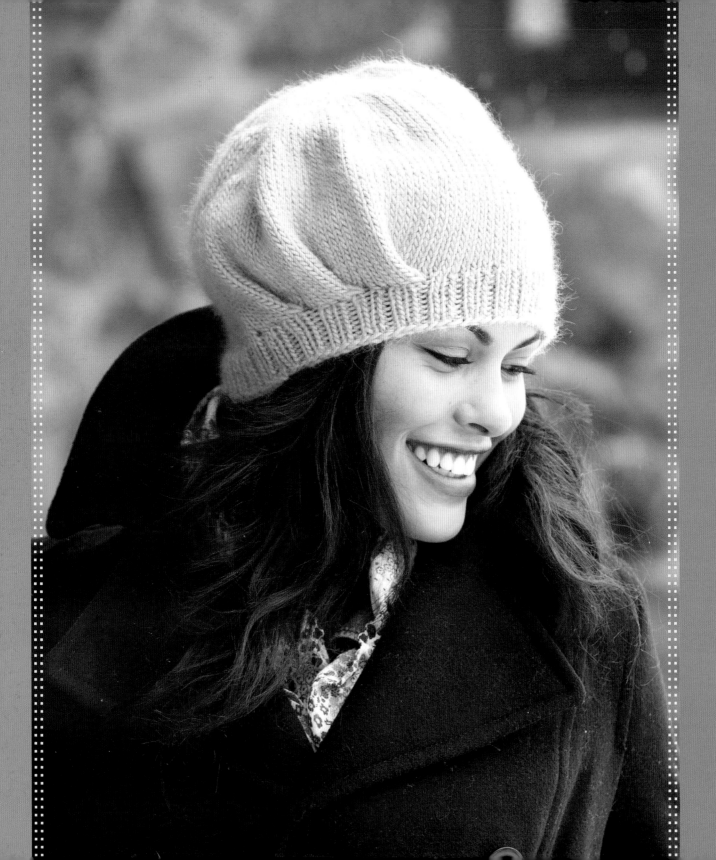

RUCHE BERET

BY SUSAN B. ANDERSON

Lovely pleats and top-down construction turn this pretty, fun-to-knit hat into something special. The yarn, a perfect complement to this hat's feminine details, has a soft halo that is enhanced by the allover stockinette stitch.

materials

YARN
Light #3 (DK weight). *Shown here:* Blue Sky Alpacas Suri Merino (60% baby suri, 40% merino; 100 g/164 yds/150 m): #415 harvest, 1 skein.

NEEDLES
U.S. size 7 (4.5 mm): 16" (40 cm) circular (cir) and set of four double-pointed (dpn). Adjust needle sizes if necessary to obtain the correct gauge.

GAUGE
20 sts and 28 rnds = 4" (10 cm) in St st.

NOTIONS
Removable stitch marker (m); tapestry needle.

FINISHED SIZE
19¼" (49 cm) circumference at brim; to fit 19–22" (48.5–56 cm) head circumference.

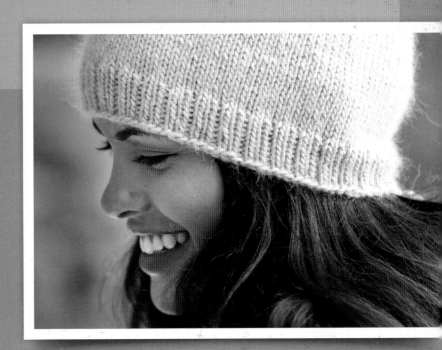

BODY

With dpns, CO 9 sts. Distribute sts evenly over 3 dpn. Join for working in the end, being careful not to twist sts. Place marker (pm) in first st of rnd.

SHAPE CROWN

Rnd 1: Knit.

Rnd 2: *[K1, M1 (see Glossary)] 2 times, k1; rep from * to end—5 sts on each dpn; 15 sts total.

Rnds 3 and 4: Knit.

Rnd 5: *[K1, M1] 4 times, k1; rep from * to end—9 sts per on each dpn; 27 sts total.

Rnd 6: Knit.

Rnd 7: *[K1, M1] 8 times, k1; rep from * to end—17 sts on each dpn; 51 sts total.

Rnds 8–10: Knit.

Rnd 11: *[K4, m1] 4 times, k1; rep from * to end—21 sts on each dpn; 63 sts total.

Rnd 12: Knit.

Rnd 13: *[K4, m1] 5 times, k1; rep from * to end—26 sts on each dpn; 78 sts total.

Rnds 14–16: Knit.

Change to cir needle. Remove removable m from fabric and pm onto needle for beg of rnd.

Rnd 17: *K5, M1; rep from * to last 3 sts of rnd, k3— 93 sts.

Rnd 18: Knit.

Rnd 19: [K1, M1] twice, knit to the last st of rnd, M1, k1— 96 sts total.

Rnd 20: Knit.

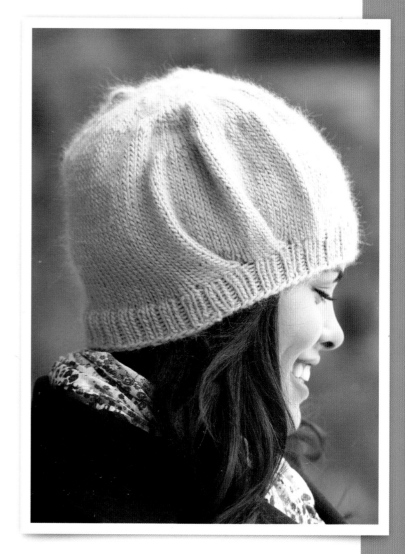

Rnd 21: *K1, [M1, k1] 4 times; rep from * 3 more times, knit to end of rnd—112 sts.

Knit 8 rnds.

Next rnd: [K2, M1] 15 times, knit to end of rnd—127 sts.

Work in St st until piece measures 8" (20.5 cm) from CO.

Next rnd: (pleating rnd) *Sl 5 sts to spare dpn; sl next 5 sts to another spare dpn; hold dpns with WS tog to form pleat, then hold 2 dpns parallel to, and in front of cir needle; [knit tog 1 st on cir needle and 1 st on each dpn] 5 times; rep from * 2 more times, knit to end of rnd—96 sts rem.

BRIM

Rnd 1: *K2, p1; rep from * to end.

Rep last rnd 7 more times.

BO all sts loosely in rib patt.

FINISHING

Weave in ends. Block if desired.

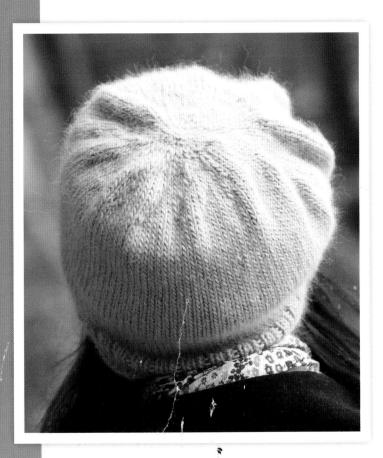

Tips and Techniques:

RAISED MAKE ONE— LEFT SLANT (M1 OR M1L)

Note: Use the left slant if no direction of slant is specified.

With left needle tip, lift the strand between the last knitted stitch and the first stitch on the left needle from front to back **(Figure 1)**, then knit the lifted loop through the back **(Figure 2)**.

FIGURE 1

FIGURE 2

RUCHE BERET

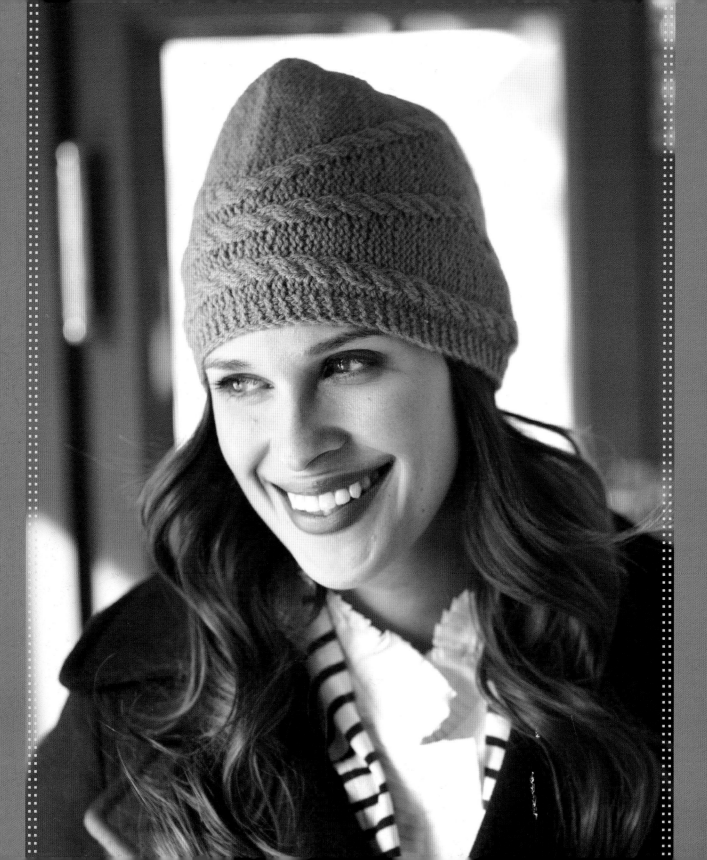

DRIFT TOQUE

BY JOCELYN J. TUNNEY

Meandering cables flow beautifully around this cleverly constructed hat that is knit side to side with short-rows for a modern shape. The organic wool yarn highlights the cables, while giving the hat an appealing rustic look.

materials

YARN
Light #3 (DK weight).
Shown here: O-Wool Legacy DK (100% certified organic merino; 152 yd [140 m]/50 g): #2362 clay, 1 ball.

NEEDLES
U.S. size 4 (3.5 mm). Adjust needle size if necessary to obtain the correct gauge.

NOTIONS
Cable needle (cn); tapestry needle.

GAUGE
22 sts and 32 rows = 4" (10cm) in Rev St st. The row gauge is more important for the correct fit of the hat than the stitch gauge.

FINISHED SIZE
18" (45.5 cm) brim circumference; to fit 18½–21" (47–53.5 cm) head circumference.

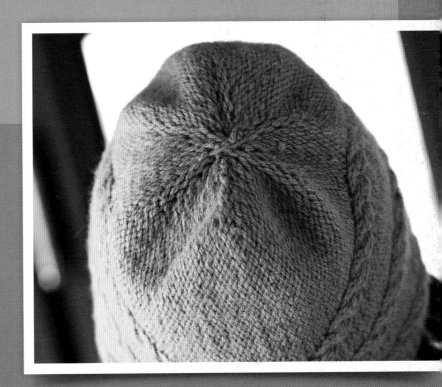

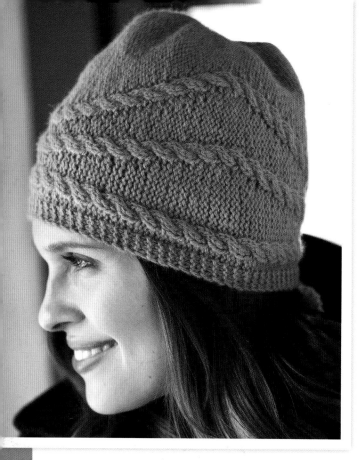

BODY

Using provisional method (see Glossary), CO 48 sts.

Work Traveling Cables chart Rows 1–72 hiding wrapped sts as they appear, then rep Rows 1–71 once more. (*Note:* Odd-numbered rows are WS rows and even-numbered rows are RS rows).

FINISHING

Remove provisional CO and place revealed sts on second needle so that both needles face in same direction. Use Kitchener st (see Glossary) to graft CO row to last row. Sew together opening at top of hat as foll: with length of yarn threaded on tapestry needle, thread needle through the end st of each row along the right side edge of piece (side with the decs). Pull snug to tighten, and fasten off inside.

Weave in ends. Block piece.

Chart Key

□	knit on RS, purl on WS		╱	k2tog
⊡	purl on RS, knit on WS		⊟	wrap and turn
☑	sl 1 pwise wyf		▧	no stitch
⬦	knit 1 st in front and back of next st			sl 2 sts onto cn, hold in back; k2; k2 from cn

Tips and Techniques: WRAP AND TURN (W&T)

A technique referred to as a "wrap and turn" is used when working short-rows. Short-rows are used to add extra fabric only to sections of the piece that you are knitting. To do this, you must wrap and turn so that you are not working an entire row or round. To work a wrap and turn with the yarn held in the back of the work, slip the first stitch from the left-hand needle onto the right-hand needle. Then bring the yarn between the needles and to the front of the work. Continuing to hold the yarn in the front of the work, return the slipped stitch to the left-hand needle. Then turn your piece so that the other side is facing you and begin working as described in the pattern. The stitch on the left-hand needle has been "wrapped" with a loop of yarn.

Traveling Cables Chart

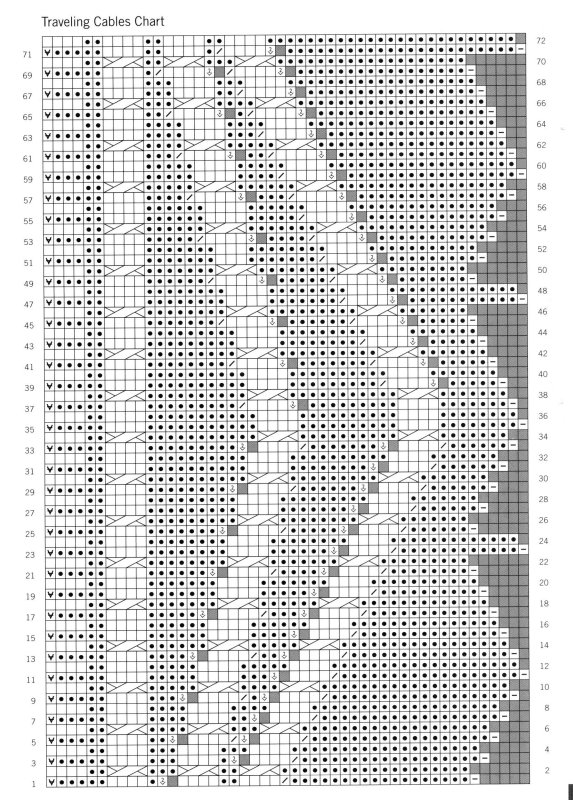

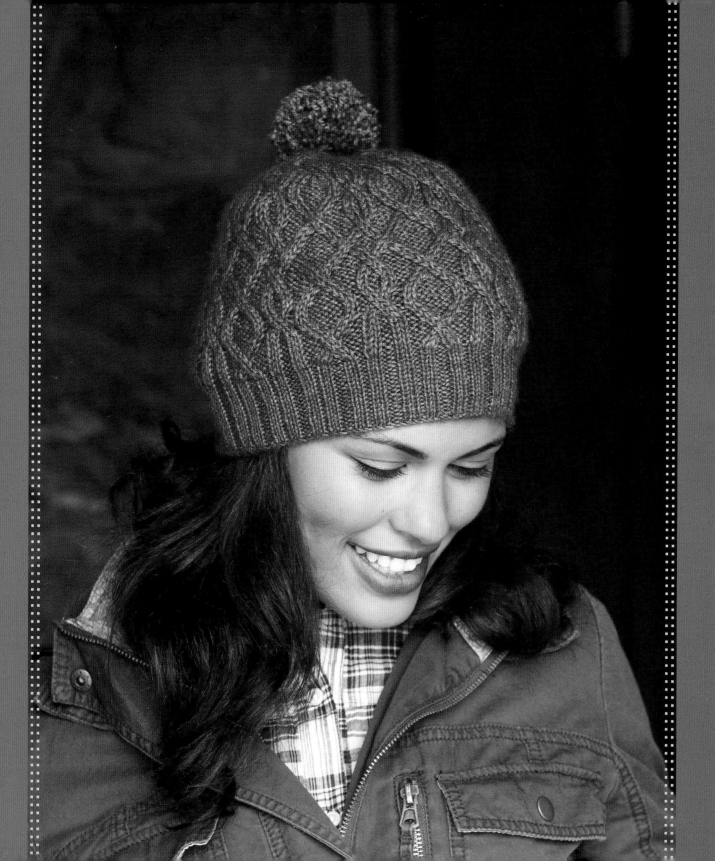

GLASHUTTE HAT

BY KATE GAGNON OSBORN

Intricate cables make for an exciting knit as they flow beautifully into the decreases of this modern take on a traditional winter hat. A pom-pom adds whimsical detail reminiscent of winter hats from our childhoods, while a bit of slouch gives it relaxed, contemporary appeal.

materials

YARN
Fine #2 (sportweight). *Shown here:* The Fibre Company Road to China Light (65% baby alpaca, 15% silk, 10% camel, 10% cashmere; 159 yd [145 m]/50 g): carnelian, 2 skeins.

NEEDLES
Brim—U.S. size 2 (2.75 mm): 16" (40 cm) circular (cir). *Body—U.S. size 4 (3.5 mm):* 20" (50 cm) cir and set of 4 double-pointed (dpn). Adjust needle sizes if necessary to obtain the correct gauge.

NOTIONS
Markers (m); tapestry needle.

GAUGE
30 sts and 40 rnds = 4" (10 cm) in ribbing on smaller needles; 2 cable repeats (40 sts) and 29 rnds = 4" (10 cm) on larger needles.

FINISHED SIZE
18¾" (47.5 cm) circumference at brim; to fit 19½–23" (49.5–58.5 cm) head circumference

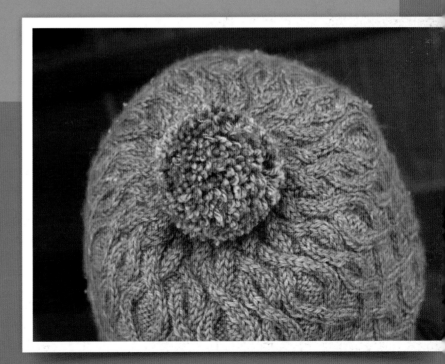

109

BRIM

With smaller needle, CO 140 sts. Join for working in the rnd, being careful not to twist sts.

Ribbing rnd: *P1, k2, p2, k2; rep from * to end.

Rep Ribbing rnd until piece measures 1¾" (4.5 cm) from CO edge.

BODY

Work Rnds 1–7 of Ribbing Increase Chart—200 sts. Change to larger needle. *Note:* Switch to dpns when there are too few sts to work comfortably on cir needle.

Work Rnds 1–39 of Hat Chart—120 sts rem.

SHAPE CROWN

Work Rnds 1–6 of Hat Decrease Chart—60 sts rem.

Next rnd: *K2tog, k1; rep from * to end—40 sts.

Next rnd: Remove m, sl 1, replace m, *k2tog; rep from * to end—20 sts rem.

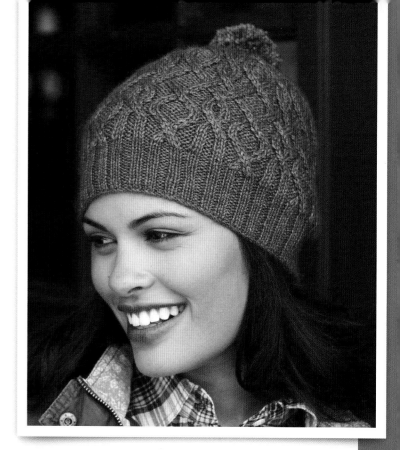

Tips and Techniques: CHOOSING THE RIGHT YARN FOR YOUR HAT

When substituting yarns in a hat pattern, there are a few things to consider. First, make sure the yarn you choose is the same yarn weight and will get the same gauge as called for in the pattern. Another factor to consider is the fabric you are trying to achieve. Does your hat style require a stiff fabric? Or does it have a relaxed shape that calls for a little drape?

Drape is a term that describes the way the knitted fabric will hang. Fibers such as silk, alpaca, and bamboo, or blends that contain these fibers, will have more drape than a fiber such as wool, which will hold its shape. For a hat with a firm brim, wool or a wool blend will help it maintain its shape. In a slouchy hat or beret, a yarn with some drape will give it a more relaxed, slouchy look. To make your hat look the most like the original sample, try to choose fibers that are similar to what the designer used.

Next rnd: *K2tog; rep from * to end—10 sts rem.

Next rnd: *K2tog; rep from * to end—5 sts rem.

Break yarn, leaving an 8" (20.5 cm) tail. Thread tail onto tapestry needle and draw through rem sts, pull snug to tighten, and fasten off inside.

FINISHING

Weave in ends. Block to measurements. Make a 2½" (6.5 cm) pom-pom (see Glossary). Attach to top.

☐	knit
⊡	purl
⧄	p2tog
P	M1P
▨	sl st(s) at end of the rnd to the right needle; remove m, return slipped sts to left needle. Replace m in center of next cable worked; for all other reps, keep in pattern, k the k sts and p the p sts.
▨	sl 1 st at beg of rnd
◪	sl 2 sts onto cn, hold in back; k2; p2 from cn
◪	sl 2 sts onto cn, hold in front; p2; k2 from cn
◪	sl 2 sts onto cn, hold in front; k2; k2 from cn
◪	sl 2 sts onto cn, hold in front; k2tog; k2 from cn
◪	sl 2 sts onto cn, hold in back; k2; k2tog from cn
◪	sl 1 st onto cn, hold in back; k2; p1 from cn
◪	sl 2 sts onto cn, hold in front; p1; k2 from cn
◪	sl 2 sts onto cn, hold in back; k2; k2 from cn
◪	sl 1 st onto cn, hold in back; k1; p1 from cn
◪	sl 1 st onto cn, hold in front; k2tog; k1 from cn
▩	no stitch
☐	pattern repeat

Ribbing Increase Chart

Hat Chart

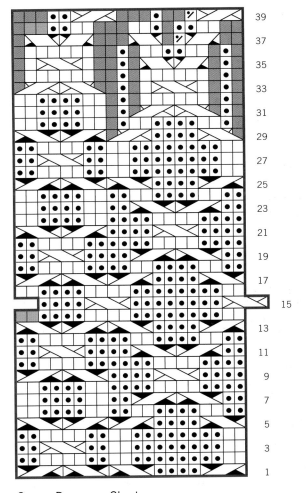

Crown Decrease Chart

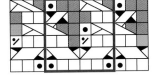

Glossary

Abbreviations

beg	begin(s); beginning	**M1**	make one (increase)		and knit together from this position (1 stitch decrease)
BO	bind off	**p**	purl		
CC	contrasting color	**p1f&b**	purl into front and back of same stitch	**st(s)**	stitch(es)
cm	centimeter(s)			**St st**	stockinette stitch
cn	cable needle	**patt(s)**	pattern(s)	**tbl**	through back loop
CO	cast on	**psso**	pass slipped stitch over	**tog**	together
cont	continue(s); continuing	**p2sso**	pass 2 slipped stitches over	**WS**	wrong side
dec(s)	decrease(s); decreasing	**pwise**	purlwise, as if to purl	**wyb**	with yarn in back
dpn	double-pointed needles	**rem**	remain(s); remaining	**wyf**	with yarn in front
foll	follow(s); following	**rep**	repeat(s); repeating	**yd(s)**	yard(s)
g	gram(s)	**rev St st**	reverse stockinette stitch	**yo**	yarnover
inc(s)	increase(s); increasing	**rnd(s)**	round(s)	*****	repeat starting point
k	knit	**RS**	right side	*** ***	repeat all instructions between asterisks
k1f&b	knit into the front and back of same stitch	**sl**	slip		
		sl st	slip st (slip 1 stitch purlwise unless otherwise indicated)	**()**	alternate measurements and/or instructions
kwise	knitwise, as if to knit				
m	marker(s)	**ssk**	slip 2 stitches knitwise, one at a time, from the left needle to right needle, insert left needle tip through both front loops	**[]**	work instructions as a group a specified number of times
MC	main color				
mm	millimeter(s)				

Bind-Offs

Standard Bind-Off

Knit the first stitch, *knit the next stitch (2 stitches on right needle), insert left needle tip into first stitch on right needle **(Figure 1)** and lift this stitch up and over the second stitch **(Figure 2)** and off the needle **(Figure 3)**. Repeat from * for the desired number of stitches.

figure 1

figure 2

figure 3

Three-Needle Bind-Off

Place the stitches to be joined onto two separate needles and hold the needles parallel so that the right sides of knitting face together. Insert a third needle into the first stitch on each of two needles **(Figure 1)** and knit them together as 1 stitch **(Figure 2)**, *knit the next stitch on each needle the same way, then use the left needle tip to lift the first stitch over the second and off the needle **(Figure 3)**. Repeat from * until no stitches remain on first two needles. Cut yarn and pull tail through last stitch to secure.

figure 1

figure 2

figure 3

Cables

Slip the designated number of stitches (usually 2 or 3) onto a cable needle, hold the cable needle in front of the work for a left-leaning twist **(Figure 1)** or in back of the work for a right-leaning twist **(Figure 2)**, work the specified number of stitches from the left needle (usually the same number of stitches that were placed on the cable needle), then work the stitches from the cable needle in the order in which they were placed on the needle **(Figure 3)**.

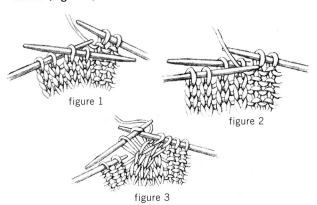

figure 1

figure 2

figure 3

Cast-Ons

Backward-Loop Cast-On

*Loop working yarn and place it on needle backward so that it doesn't unwind. Repeat from *.

Cable Cast-On

If there are no stitches on the needles, make a slipknot of working yarn and place it on the needle, then use the knitted method (see below) to cast on 1 more stitch—2 stitches on needle. Hold needle with working yarn in your left hand. *Insert right needle between the first 2 stitches on left needle **(Figure 1)**, wrap yarn around needle as if to knit, draw yarn through **(Figure 2)**, and place new loop on left needle **(Figure 3)** to form a new stitch. Repeat from * for the desired number of stitches, always working between the 2 stitches closest to the tip of the left needle.

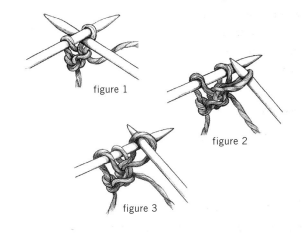

figure 1

figure 2

figure 3

Cast-On for Crown of Hat

This method for casting on for a circle in the round is invisible. Leaving a tail, make a large loop with the yarn. Hold the loop so that the crossing area of the loop is on the top and the tail is off to the left. With a double-pointed knitting needle, *reach inside the loop and pull the yarn coming from the ball through to make a stitch, then take the needle up over the top of the loop and yarn over; repeat from * until you have the desired number of stitches on the needle. Turn and knit one row. If you're casting on an even number of stitches, the sequence ends with a yarnover, and it will be difficult to keep from losing the last stitch. To solve this, pick up 1 extra stitch from the inside and then work these last 2 stitches together on the first row to get back to an even number of stitches. Divide the stitches evenly onto four double-pointed needles.

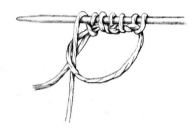

Crochet Cast-On

Place a slipknot on a crochet hook. Hold the needle and yarn in your left hand with the yarn under the needle. Place hook over needle, wrap yarn around hook, and pull the loop through the slipknot (**Figure 1**). *Bring yarn to back under needle tip, wrap yarn around hook, and pull it through loop on hook (**Figure 2**). Repeat from * until there is one less than the desired number of stitches. Bring the yarn to the back and slip the remaining loop from the hook onto the needle.

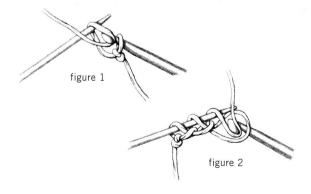

figure 1

figure 2

Knitted Cast-On

Make a slipknot of working yarn and place it on the left needle if there are no stitches already there. *Use the right needle to knit the first stitch (or slipknot) on left needle (**Figure 1**) and place new loop onto left needle to form a new stitch (**Figure 2**). Repeat from * for the desired number of stitches, always working into the last stitch made.

figure 1 figure 2

Long-Tail (Continental) Cast-On

Leaving a long tail (about ½" [1.3 cm] for each stitch to be cast on), make a slipknot and place on right needle. Place thumb and index finger of your left hand between the yarn ends so that working yarn is around your index finger and tail end is around your thumb and secure the yarn ends with your other fingers. Hold your palm upward, making a V of yarn (**Figure 1**). *Bring needle up through loop on thumb (**Figure 2**), catch first strand around index finger, and go back down through loop on thumb (**Figure 3**). Drop loop off thumb and, placing thumb back in V configuration, tighten resulting stitch on needle (**Figure 4**). Repeat from * for the desired number of stitches.

figure 1 figure 2

figure 3 figure 4

Provisional Cast-On

Place a loose slipknot on the needle held in your right hand. Hold the waste yarn next to the slipknot and around the left thumb; hold working yarn over left index finger. * Bring the right needle forward under waste yarn, over working yarn, grab a loop of working yarn **(Figure 1)**, then bring the needle to the front, over both yarns, and grab a second loop **(Figure 2)**. Repeat from * for desired number of stitches.

figure 1 figure 2

Tubular Cast-On

Using waste yarn, cast on half the number of sts for your pattern and join to work in rnds. Knit 4 rnds. Drop the waste yarn end and attach the main yarn that you'll use in the pattern. Knit 4 rnds. Turn your work so that the wrong side is facing. To start creating the tube, purl the first stitch on the left-hand needle **(figure 1)**. *With the left-hand needle, pick up the first purl bump from the first row of main yarn and knit it **(figure 2)**. Purl 1 stitch from left-hand needle. Repeat from * until all stitches from the left-hand needle have been purled. Snip a few strands of waste yarn and begin to pick out all waste yarn from the main yarn. Once all waste yarn has been removed, you'll have a beautiful tubular finished edge.

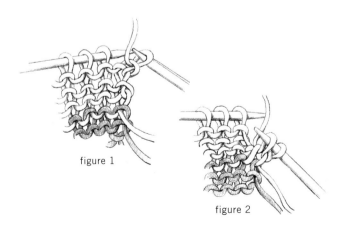

figure 1

figure 2

Crochet

Crochet Chain (ch)

Make a slipknot and place it on crochet hook if there isn't a loop already on the hook. *Yarn over hook and draw through loop on hook. Repeat from * for the desired number of stitches. To fasten off, cut yarn and draw end through last loop formed.

Single Crochet (sc)

*Insert hook into the second chain from the hook (or the next stitch), yarn over hook and draw through a loop, yarn over hook **(Figure 1)**, and draw it through both loops on hook **(Figure 2)**. Repeat from * for the desired number of stitches.

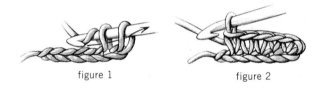

figure 1 figure 2

Slip-Stitch Crochet (sl st)

*Insert hook into stitch, yarn over hook and draw a loop through both the stitch and the loop already on hook. Repeat from * for the desired number of stitches.

Decreases

Centered Double Decrease (sl 2, k1, p2sso)

Slip 2 stitches together knitwise **(Figure 1)**, knit the next stitch **(Figure 2)**, then pass the slipped stitches over the knitted stitch **(Figure 3)**.

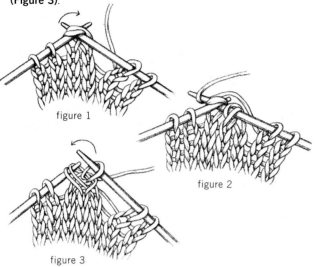

figure 1

figure 2

figure 3

Knit 2 Together (k2tog)

Knit 2 stitches together as if they were a single stitch.

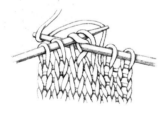

Knit 2 Together through Back Loops (k2tog tbl)

Knit 2 stitches together through the back loops as if they were a single stitch.

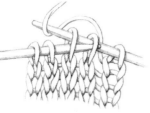

Knit 3 Together (k3tog)

Knit 3 stitches together as if they were a single stitch.

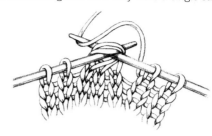

Knit 4 Together (k4tog)

Knit 4 stitches together as if they were a single stitch.

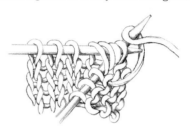

Left-Slant Double Decrease (sl 1, k2tog, psso)

Slip 1 stitch knitwise to right needle, knit the next 2 stitches together **(Figure 1)**, then use the tip of the left needle to lift the slipped stitch up and over the knitted stitches **(Figure 2)**, then off the needle.

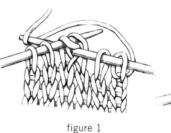

figure 1

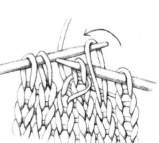

figure 2

Left-Slant Triple Decrease (sl 1, k3tog, psso)

Work as for Left-Slant Double Decrease, but knit 3 stitches together instead of 2 stitches.

Left-Slant Quadruple Decrease (sl 1, k4tog, psso)

Work as for Left-Slant Double Decrease, but knit 4 stitches together instead of 2 stitches.

Purl 2 Together (p2tog)

Purl 2 stitches together as if they were a single stitch.

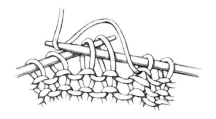

Slip, Slip, Knit (ssk)

Slip 2 stitches individually knitwise **(Figure 1)**, insert left needle tip into the front of these 2 slipped stitches, and use the right needle to knit them together through their back loops **(Figure 2)**.

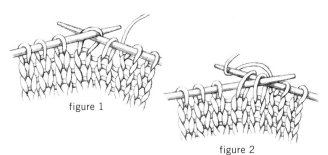

figure 1

figure 2

Slip, Slip, Slip, Knit (sssk)

Slip 3 stitches individually knitwise **(Figure 1)**, insert left needle tip into the front of these 3 slipped stitches, and use the right needle to knit them together through their back loops **(Figure 2)**.

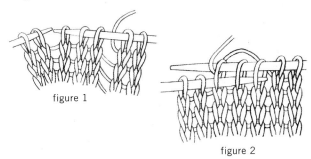

figure 1

figure 2

Slip, Slip, Purl (ssp)

Holding yarn in front, slip 2 stitches individually knitwise **(Figure 1)**, then slip these 2 stitches back onto left needle (they will be turned on the needle) and purl them together through their back loops **(Figure 2)**.

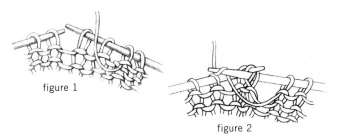

figure 1

figure 2

Gauge

Measuring Gauge

Knit a swatch at least 4" (10 cm) square. Remove the stitches from the needles or bind them off loosely and lay the swatch on a flat surface. Place a ruler over the swatch and count the number of stitches across and number of rows down (including fractions of stitches and rows) in 2" (5 cm) and divide this number by two to get the number of stitches (including fractions of stitches) in one inch. Repeat two or three times on different areas of the swatch to confirm the measurements. If you have more stitches and rows than called for in the instructions, knit another swatch with larger needles; if you have fewer stitches and rows, knit another swatch with smaller needles.

Grafting

Kitchener Stitch

Arrange stitches on two needles so that there is the same number of stitches on each needle. Hold the needles parallel to each other with wrong sides of the knitting together. Allowing about ½" (1.3 cm) per stitch to be grafted, thread matching yarn on a tapestry needle. Work from right to left as follows:

STEP 1. Bring tapestry needle through the first stitch on the front needle as if to purl and leave the stitch on the needle **(Figure 1)**.

STEP 2. Bring tapestry needle through the first stitch on the back needle as if to knit and leave that stitch on the needle **(Figure 2)**.

STEP 3. Bring tapestry needle through the first front stitch as if to knit and slip this stitch off the needle, then bring tapestry needle through the next front stitch as if to purl and leave this stitch on the needle **(Figure 3)**.

STEP 4. Bring tapestry needle through the first back stitch as if to purl and slip this stitch off the needle, then bring tapestry needle through the next back stitch as if to knit and leave this stitch on the needle **(Figure 4)**.

Repeat Steps 3 and 4 until 1 stitch remains on each needle, adjusting the tension to match the rest of the knitting as you go. To finish, bring tapestry needle through the front stitch as if to knit and slip this stitch off the needle, then bring tapestry needle through the back stitch as if to purl and slip this stitch off the needle.

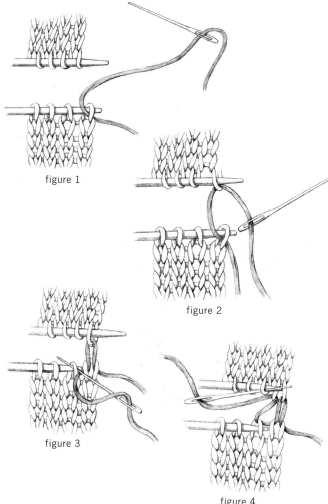

figure 1

figure 2

figure 3

figure 4

I-Cord (also called Knit-Cord)

Using two double-pointed needles, cast on the desired number of stitches (usually 3 to 4). *Without turning the needle, slide stitches to other end of needle, pull the yarn around the back, and knit the stitches as usual. Repeat from * for desired length.

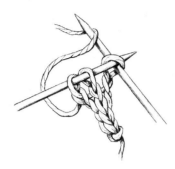

Applied I-Cord

As I-cord is knitted, attach it to the garment as follows: With garment right side facing and using a separate ball of yarn and circular needle, pick up and knit the desired number of stitches along the garment edge. Slide these stitches down the needle so that the first picked-up stitch is near the opposite needle point. With double-pointed needle, cast on the desired number of I-cord stitches. *Knit across the I-cord to the last stitch, then knit the last stitch together with the first picked-up stitch on the garment, and pull the yarn behind the cord. Repeat from * until all picked-up stitches have been used.

Reverse Stockinette Stitch I-Cord (or Knit-Cord)

Work as for regular knit-cord (or I-cord) but purl the stitches instead of knitting them.

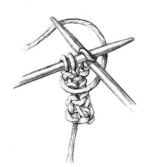

Increases

Double Increase—Knit 1 Through Front, then Back, then Front Again (k1f/b/f)

Knit into a stitch but leave it on the left needle **(Figure 1)**, then knit through the back loop of the same stitch **(Figure 2)** and leave it on the left needle, then knit through the front loop of the same stitch again **(Figure 3)** and slip the original stitch off the left needle **(Figure 4)**.

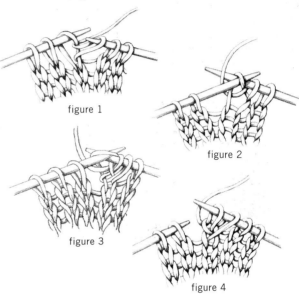

figure 1

figure 2

figure 3

figure 4

Knit 1 Through Front and Back (k1f&b)

Knit into a stitch but leave it on the left needle **(Figure 1)**, then knit through the back loop of the same stitch **(Figure 2)** and slip the original stitch off the needle **(Figure 3)**.

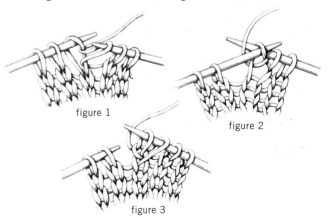

figure 1

figure 2

figure 3

Lifted Increase—Left Slant (LLI)

Insert left needle tip into the back of the stitch below the stitch just knitted **(Figure 1)**, then knit this stitch **(Figure 2)**.

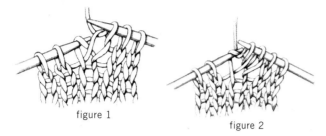

figure 1

figure 2

Lifted Increase—Right Slant (RLI)

Note: If no slant direction is specified, use the right slant. Knit into the back of the stitch (in the "purl bump") in the row directly below the stitch on the needle **(Figure 1)**, then knit the stitch on the needle **(Figure 2)**, and slip the original stitch off the needle.

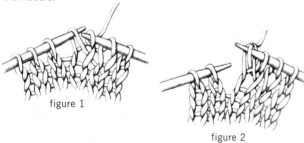

figure 1

figure 2

Purl 1 Through Front and Back (p1f&b)

Purl into a stitch but leave it on the left needle **(Figure 1)**, then purl through the back loop of the same stitch **(Figure 2)** and slip the original stitch off the needle.

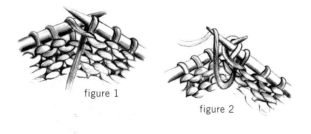

figure 1

figure 2

Raised Make One—Left Slant (M1 or M1L)

Note: Use the left slant if no direction of slant is specified. With left needle tip, lift the strand between the last knitted stitch and the first stitch on the left needle from front to back **(Figure 1)**, then knit the lifted loop through the back **(Figure 2)**.

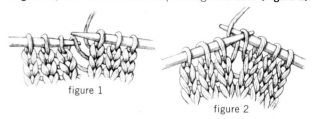

figure 1

figure 2

Raised Make One Purlwise (M1 or M1P)

With left needle tip, lift the strand between the needles from front to back, then purl the lifted loop through the front.

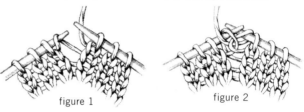

figure 1

figure 2

Raised Make One—Right Slant (M1R)

With left needle tip, lift the strand between the needles from back to front **(Figure 1)**. Knit the lifted loop through the front **(Figure 2)**.

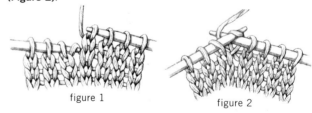

figure 1

figure 2

Yarnovers

Backward yarnover

Bring the yarn to the back under the needle, then over the top to the front so that the leading leg of the loop is at the back of the needle.

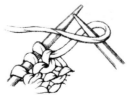

Yarnover between 2 knit stitches

Wrap the working yarn around the needle from front to back and in position to knit the next stitch.

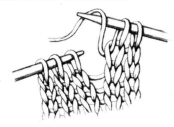

Yarnover after a knit before a purl

Wrap the working yarn around the needle from front to back, then under the needle to the front again in position to purl the next stitch.

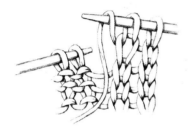

Yarnover between 2 purl stitches

Wrap the working yarn around the needle from front to back, then under the needle to the front in position to purl the next stitch.

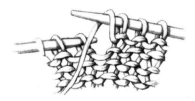

Yarnover after purl before knit

Wrap the working yarn around the needle from front to back and in position to knit the next stitch.

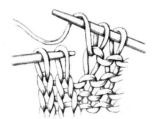

Knit Through Back Loop (tbl)

Insert right needle through the loop on the back of the left needle from front to back, wrap the yarn around the needle, and pull a loop through while slipping the stitch off the left needle. This is similar to a regular knit stitch but is worked into the back loop of the stitch instead of the front.

Pick Up and Knit

Pick Up and Knit

With right side facing and working from right to left, insert the tip of the needle into the center of the stitch below the cast-on edge (**Figure 1**), wrap yarn around needle, and pull through a loop (**Figure 2**). Pick up 1 stitch for every existing stitch.

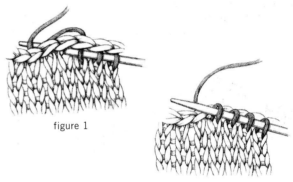

figure 1

figure 2

Pick Up and Purl

With the wrong side of the work facing and working from right to left, * insert the right-hand needle tip under the edge stitch from the far side to the near side, wrap the yarn around the needle, and pull a loop through. Repeat from * for the desired number of stitches.

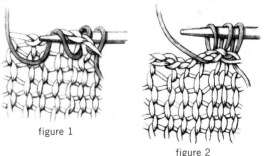

figure 1

figure 2

Pom-Pom

Cut two circles of cardboard, each ½" (1.3 cm) larger than desired finished pom-pom width. Cut a small circle out of the center and a small wedge out of the side of each circle **(Figure 1)**. Tie a strand of yarn between the circles, hold circles together and wrap with yarn—the more wraps, the thicker the pom-pom. Cut between the circles and knot the tie strand tightly **(Figure 2)**. Place pom-pom between two smaller cardboard circles held together with a needle and trim the edges **(Figure 3)**. This technique comes from Nicky Epstein's *Knitted Embellishments*, Interweave, 1999.

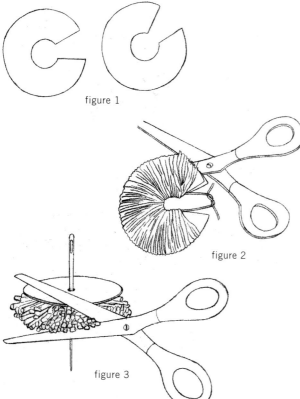

figure 1

figure 2

figure 3

Running Stitch

The most common sewing method. Holding the pieces to be joined together, pass a threaded needle from WS to RS and back, creating stitches that look like a small dashed line of equal lengths on both sides.

Short-Rows

Short-Rows Knit Side

Work to turning point, slip next stitch purlwise **(Figure 1)**, bring the yarn to the front, then slip the same stitch back to the left needle **(Figure 2)**, turn the work around and bring the yarn in position for the next stitch—1 stitch has been wrapped, and the yarn is correctly positioned to work the next stitch. When you come to a wrapped stitch on a subsequent row, hide the wrap by working it together with the wrapped stitch as follows: Insert right needle tip under the wrap (from the front if wrapped stitch is a knit stitch; from the back if wrapped stitch is a purl stitch; **Figure 3**), then into the stitch on the needle, and work the stitch and its wrap together as a single stitch.

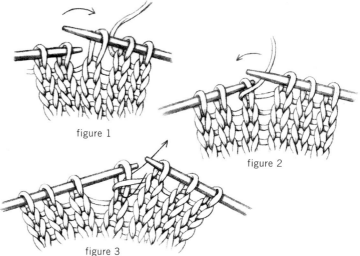

figure 1

figure 2

figure 3

Short-Rows Purl Side

Work to the turning point, slip the next stitch purlwise to the right needle, bring the yarn to the back of the work **(Figure 1)**, return the slipped stitch to the left needle, bring the yarn to the front between the needles **(Figure 2)**, and turn the work so that the knit side is facing—1 stitch has been wrapped, and the yarn is correctly positioned to knit the next stitch. To hide the wrap on a subsequent purl row, work to the wrapped stitch, use the tip of the right needle to pick up the wrap from the back, place it on the left needle **(Figure 3)**, then purl it together with the wrapped stitch.

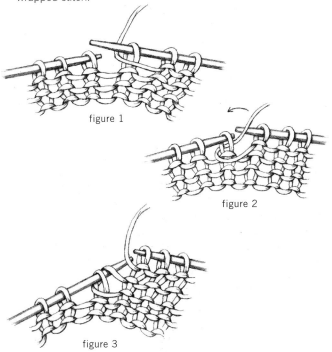

figure 1

figure 2

figure 3

Weave In Loose Ends

Thread the ends on a tapestry needle and trace the path of a row of stitches **(Figure 1)** or work on the diagonal, catching the back side of the stitches **(Figure 2)**. To reduce bulk, do not weave two ends in the same area. To keep color changes sharp, work the ends into areas of the same color.

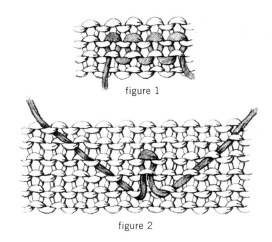

figure 1

figure 2

Wrap and Turn (w&t)

Knit row—Slip next stitch purlwise onto right-hand needle **(Figure 1)**, bring yarn to front of work, return slipped stitch to left-hand needle, bring yarn to back of work **(Figure 2)**, then turn work. Purl back to beginning of row.

figure 1

figure 2

Contributing Designers

Susan B. Anderson lives and knits in Madison, Wisconsin. She is currently the curator for the *Spud says!* blog, she writes her own blog, susanbanderson.blogspot .com, and she designs for her online pattern shop as well as for yarn companies. Susan is the author of *Itty-Bitty Hats, Itty-Bitty Nursery, Itty-Bitty Toys,* and *Spud & Chloë at the Farm.*

Connie Chang Chinchio is a knitwear designer living and working in the New York City area. She has written a book that will be out soon and maintains a website that she hopes to update more often, conniechangchinchio.com/blog.

Jared Flood is a knitwear designer, photographer, and yarn developer based in Brooklyn, New York. He designs for his label, Brooklyn Tweed, and released his first line of American Wool in fall 2010. See more of his work at brooklyntweed.net.

Tanis Gray is a graduate of Rhode Island School of Design and has worked at HBO, Martha Stewart, and *Vogue Knitting.* With almost 200 published knitting designs and two books under her belt, she lives on Capitol Hill in Washington, D.C. Follow her work at tanisknits.com.

Carrie Bostick Hoge lives in Maine with her husband and daughter. She is part of the team at Quince and Co. You can find more about her work at her blog, swatchdiaries.blogspot.com and her website, maddermade.com.

Laura Irwin designs a ready-to-wear handknit line and is the author of *Boutique Knits.* Her patterns have been featured in magazines, *HGTV, Knitting Daily TV,* and in the book *Bag Style.* She recently opened a retail shop-showroom-studio with Holly Stalder and Rachael Donaldson in Portland, Oregon, where she produces and sells her work.

Gudrun Johnston is a knitwear designer of Scottish origin currently residing in Massachusetts. Her design work is greatly influenced by her Shetland Island heritage. Read more about her on her website, theshetlandtrader.com.

Kirsten Kapur is an independent knitwear designer living with her husband and three teenage children in northwestern New Jersey. She blogs about knitting at throughtheloops .typepad.com.

Courtney Kelley lives in Philadelphia and is co-owner of Kelbourne Woolens, distributors of The Fibre Company's yarns. Her patterns have been published in publications such as *Interweave Crochet, Knitscene,* and *Interweave Knits,* and she is coauthor of *Vintage Modern Knits.* Courtney blogs at kelbournewoolens.com/blog.

Jennifer Lang-MacKenzie is a knitwear designer, sometimes painter, and stay-at-home mom living in Alberta, Canada. She blogs about knitting and other things at sadieandoliver.ca.

Natalie Larson is mother to three little ones and is an independent knitwear designer living in Las Vegas, Nevada. She has published many popular designs through her website, natalielarsondesigns.com.

Anne Kuo Lukito is a knitwear designer living in Southern California. Her designs have appeared in publications including *Knitty, Interweave Knits, Twist Collective, Luxury Yarn One-Skein Wonders, Knitting in the Sun,* and *Knitscene.* You can follow her crafty endeavors at craftydiversions.com.

Mary Jane Mucklestone is a handknitting designer and the author of *200 Fair Isle Motifs: A Knitter's Directory.* Follow her adventures in colorful knitting at her website, MaryJaneMucklestone.com.

Kate Gagnon Osborn is co-owner of Kelbourne Woolens, distributors of The Fibre Company's yarns. Her designs have appeared in *Vogue Knitting, Knitscene,* and *Interweave Knits.* She is coauthor of *Vintage Modern Knits* and blogs at kelbournewoolens.com/blog.

Elisabeth Parker lives in western Massachusetts, where her small home is gradually being taken over by various types of fiber arts and cooking paraphernalia. She can be found online at fuchsiaknits.wordpress.com.

Cirilia Rose knits and designs in the Northeast and is inspired by all things cinematic. When she isn't knitting in darkened theaters, she enjoys making messes in the kitchen and visiting friends who are scattered around the United States. You can see more of her work at ravelry.com/designers/cirilia-rose.

Kristen TenDyke is a knit and crochet designer and a technical editor from Massachusetts. When not playing with yarn, she enjoys exploring nature, studying healing arts and energy work, and online social networking. See Kristen's designs on kristentendyke.com and caterpillarknits.com.

Jocelyn Tunney is the owner of Tunney Wool Company, the distributor of O-Wool certified organic yarns available at o-wool.com. She designs and knits in Philadelphia, Pennsylvania.

Melissa Wehrle is a full-time knitwear designer living in New York City. In her free time, she designs for Neoknits and several magazines and yarn companies. You can see more of her designs at neoknits.com.

Sources for Yarn

Berroco Inc.
1 Tupperware Dr., Ste. 4
North Smithfield, RI 02896
(401) 769-1212
berroco.com
Blackstone Tweed,
Ultra Alpaca Light

Bijou Basin Ranch
PO Box 154
Elbert, CO 80106
(303) 601-7544
fax (719) 347-2254
bijoubasinranch.com
Himalayan Trail

Brown Sheep Company Inc.
100662 County Rd. 16
Mitchell, NE 69357
(800) 826-9136
fax (308) 635-2143
brownsheep.com
Lamb's Pride Worsted

Cascade Yarns
1224 Andover Pk. E.
Tukwila, WA 98188
(800) 548-1048
fax (206) 574-0436
cascadeyarns.com
Venezia Worsted

Classic Elite Yarns
122 Western Ave.
Lowell, MA 01851
(978) 453-2837
fax (978) 452-3085
classiceliteyarns.com
Ariosa

Dream in Color
dreamincoloryarn.com
Smooshy

Fibre Company Yarns
Distributed by Kelbourne
Woolens
915 N. 28th St., Second Fl.
Philadelphia, PA 19130
(215) 687-5534
fax (215) 701-5901
kelbournewoolens.com
Canopy Fingering,
Road to China Light

Manos del Uruguay
Distributed in the United
States by Fairmount Fibers
915 N. 28th St.
Philadelphia, PA 19130
(888) 566-9970
fax (215) 235-3498
fairmountfibers.com
Silk Blend

Rowan
Distributed in the United
States by Westminster Fibers
Inc.
165 Ledge St.
Nashua, NH 03060
(800) 445-9276
westminsterfibers.com
Felted Tweed, KidSilk Aura

St-Denis Yarns
Distributed in the United
States by Classic Elite Yarns
122 Western Ave.
Lowell, MA 01851
(978) 453-2837
fax (978) 452-3085
classiceliteyarns.com
stdenisyarns.com
Nordique

Sublime Yarns
Distributed by Knitting Fever
Inc.
K. F. I.
PO Box 336
315 Bayview Ave.
Amityville, NY 11701
(516) 546-3600
fax (516) 546-6871
knittingfever.com
Cashmere Merino Silk DK

Quince and Co.
Portland, ME
(877) 309-6762
quinceandco.com
Lark

Blue Sky Alpacas
PO Box 88
Cedar, MN 55011
(888) 460-8862
blueskyalpacas.com
Suri Merino

Brooklyn Tweed Yarn
brooklyntweed.net
Shelter

Malabrigo Yarn
(786) 866-6187
fax (786) 513-0397
malabrigoyarn.com
Silky Merino, Merino Worsted

Madelinetosh
7515 Benbrook Pkwy.
Benbrook, TX 76126
(817) 249-3066
fax (817) 244-2394
madelinetosh.com
Pashmina, Tosh Vintage

O-Wool
Distributed by Tunney
Wool Company
915 N. 28th St.
Philadelphia, PA 19130
(888) 673-0260
fax (888) 841-9736
o-wool.com
Legacy DK, Balance

Skacel Collection Inc.
(800) 255-1278
skacelknitting.com
Zauberball Crazy

Valley Yarns
Distributed by Webs
75 Service Center Rd.
Northampton, MA 01060
(800) 367-9327
fax (413) 584-1603
yarn.com
kangaroodyer.com
Valley Yarns Semisolid sock
by the Kangaroo Dyer

Index

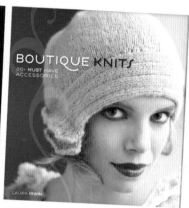